LEGENDARY LOCALS

OF

VANCOUVER

WASHINGTON

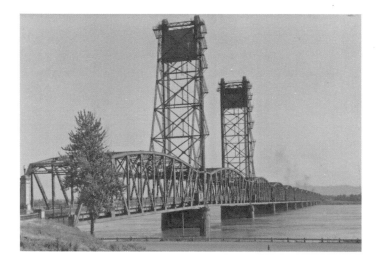

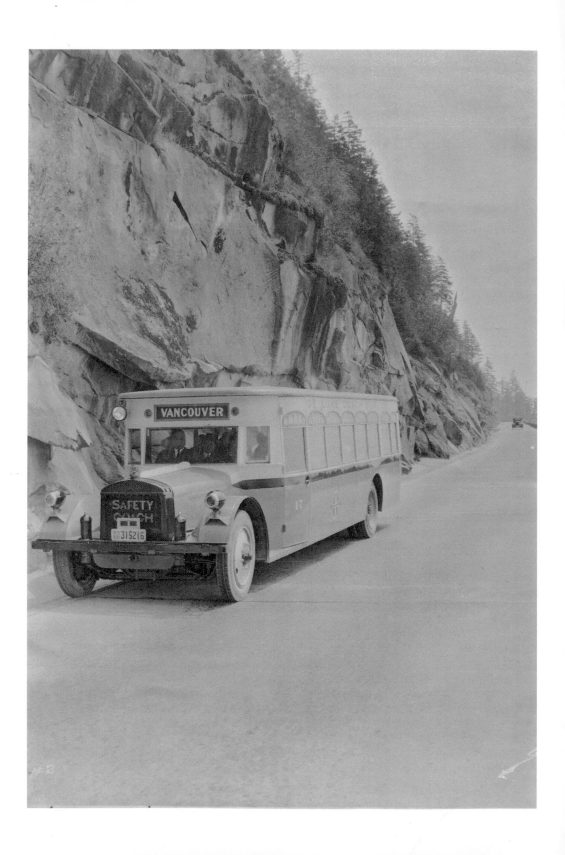

LEGENDARY LOCALS

OF

VANCOUVER

WASHINGTON

PAT JOLLOTA

LEGENDARY
LOCALS

This work is dedicated to the people of Vancouver, who accepted me as one of their own. As an adopted daughter, I cherish this family. The city of Vancouver is unique, and the longer one studies its history, the more singular it becomes

Published by Legendary Locals, an imprint of Arcadia Publishing
Charleston, South Carolina

Printed in the United States of America

Library of Congress Control Number: 2011936427

For all general information, please contact Arcadia Publishing:
Telephone 843-853-2070
Fax 843-853-0044
E-mail sales@arcadiapublishing.com
For customer service and orders:
Toll-Free 1-888-313-2665

Visit us on the Internet at www.arcadiapublishing.com

On the Cover: FROM LEFT TO RIGHT:
(TOP ROW) Emil Fries, advocate (Washington State School for the Blind, see page 111), Thomas Clarke, superintendent (Washington State School for the Blind, see page 40), Valree Joshua, teacher (Joshua Family collection, see page 81), Herbert Campbell, publisher (Campbell Family collection, see page 61), Hal Corwin, bottler (Greater Vancouver Chamber of Commerce, see page 88).
(MIDDLE ROW) POW/MIA (Gwen Hall Davis, see pages 104 and 105), Leverett Richards, journalist (*Vancouver Columbian*, see page 122), Rudolph Luepke, florist (Luepke Florist, see page 80), Royce Pollard, mayor (Pollard Family collection, see page 120), Ulysses S. Grant, president (National Park Service Fort Vancouver, see page 18).
(BOTTOM ROW) Elizabeth Ryan, nurse (Ceci Ryan Smith, see page 78), George C. Marshall, general (Library of Congress, see page 108), George Lamka, port commissioner (Port of Vancouver, see page 58), William Troup, captain (Vancouver Masonic Center, see page 58), George Goodrich, restaurateur (Greater Vancouver Chamber of Commerce, see page 110).

Page 1: In the 1950s, the Interstate Bridge was a single span, a flat, low bridge across the river that necessitated more and more bridge lifts each year. That single span is now the northbound span of the bridge. Very soon after this photograph was taken, a second span was built, and the northbound span was rebuilt with a high hump on it to allow river traffic to pass. (Author's collection.)

Page 2: A bus to Vancouver speeds along the highway on the north bank of the Columbia River in 1925. The Hageol Safety Coach bus was manufactured in Oakland, California, and featured a wide tread and a low center of gravity. Buses replaced stage lines as taxis had replaced horse-drawn cabs. (Greater Vancouver Chamber of Commerce.)

CONTENTS

ACKNOWLEDGMENTS

So many people helped with this book. I'm grateful to the families who let me borrow photographs of their loved ones: Ceci Ryan Smith, Ed Aschieris, Carol Langsdorf, Gwen Hall, Doris Hale, Tom Craig at Sparks Furniture, and Royce Pollard. Thanks to the Vancouver Masonic Center, especially Ray Zimmerman, Mary Helen Johnson, and Virgil and Verna Myers; Vancouver Elks Lodge #832, especially Skip Barnes; St. Luke's Episcopal Church; Russ Roseberry and First Presbyterian Church; Dave Ricks; the Greater Vancouver Chamber of Commerce; Kelly Parker; the *Vancouver Columbian*; the Campbell Family; Linda Lutes; and the dedicated folks of the National Park Service at the Fort Vancouver National Historic Site especially Chief Ranger Greg Shine. Also thanks to Michael Houser, the Washington State architectural historian, and Jack Burkman, who helped me unravel odd computer glitches, I'm sure that I've overlooked some, but I couldn't have done it without you! Thank you

INTRODUCTION

In 1824, the Hudson's Bay Company (HBC), led by Chief Factor Dr. John McLoughlin, proceeded upriver from Astoria to find a site on the north bank of the Columbia River near the confluence of the Willamette River. The HBC believed that the river was a natural boundary between British and American interests. Little did they know that the mighty Columbia would one day turn Vancouver into a conduit for one-third of the nation's grain exports, bringing cargo from all over the world, hydroelectric power, and industry. The river would eventually shape the area to such an extent that Vancouver would adopt Woody Guthrie's "Roll On, Columbia, Roll On" as its official folk song.

The river was the fastest and most reliable route of transportation in the early days of settlement, when roads had yet to be built and the trails that the Native Americans had worn were muddy and impassable in the winter, rough and broken in the summer. The riverbanks were also considered an ideal place for the railroad, an idea that is not so attractive today; a view of the river brings the sound of train whistles with it.

The city sprawls in a broad valley, called by Meriwether Lewis "the most desirable situation for a settlement which I have seen on the west side of the Rocky Mountains." The Cascade Mountains to the east and the Coast Range to the west protect the community from extremes of weather.

North of the original fort there lay only dense, impenetrable forest. Cottonwoods lined the bank, and conifers reigned beyond. Occasionally, particularly in marshes, there would be an opening in the forest. The Chinook would burn these over each year to keep them open for wildlife. The British called these openings "plains," while the French termed them "prairies." There were five of these plains, not counting the one that the fort occupied. Just upriver, the HBC built a gristmill and a lumber mill. They called it Mill Plain. The road that is today called Mill Plain follows that original route, as does Fourth Plain Road. The Second, Third, and Fourth Plain were northeast of the fort. The road going to Fourth Plain crossed Second Plain and Third Plain. The Fifth Plain lay still further north and is only marked by Fifth Plain Creek.

The HBC brought a diverse population with it, including French Canadians, Scots-English gentlemen, Iroquois from New York, Hawaiians, and Sandwich Islanders (or Owyheeans as they were known). In order to communicate, the inhabitants of the fort and the village used a trade dialect, called "Chinook Jargon" or "Chinook Wawa." It was a simple, easily learned language consisting of just a few hundred words. During the Civil War, officers who had served at Vancouver—forerunners of the World War II code-talkers— would use the jargon to communicate amongst themselves.

The beginning of the Oregon Trail, the vast movement west, is generally set at 1843. While some Americans made their way to the Hudson's Bay site before then, the inrush of settlers began in earnest that year. The gentlemen of the company would help them with supplies and point them south, to Oregon Country, alerting them to the division between American and British territory.

After years of saber rattling—"All of Oregon, All of Texas or War," and "54-40 or Fight"—the United States and Britain agreed to the Treaty of 1846, which drew the border between the two countries at the 49th parallel. The HBC found itself deep within American territory. The agreement gave the company until 1860 to wind up its affairs and relocate to Victoria, in what is now British Columbia. In the meantime, Dr. John McLoughlin worked with the new government, headquartered in Champoeg. When asked if he felt that the company should pay taxes for the cost of government, he replied that he would be willing to pay taxes on the goods that he sold to the settlers. That was the area's first sales tax.

The US Army arrived in 1849, fresh from the Mexican War. While historians usually concentrate on the military history of the Barracks, it's easy to forget that it was home to the soldiers and their families. There were parties and sleigh rides, joys and sorrows. The Barracks were almost like a separate community intersecting with the civilian town. Many soldiers posted to the Barracks remained after

discharge or retirement, and the city's fortunes rose and fell depending on the level of activity there. Wartime meant prosperity.

After a few years as Columbia City, Vancouver incorporated as a city in 1857, and Washington became a state in 1889. The military provided a sense of safety that encouraged settlement. Most of the men joined one of the volunteer groups, such as Captain Strong's Mounted Rangers, intended to guard settlements from attack. These organizations evolved into today's National Guard. When the Civil War began, the "Webfoot volunteers," as they called themselves, assumed positions at the Barracks as the regular army was sent east.

The river could also be a barrier. With a ferryboat as the only way to cross the river, growth stalled. When at last the railroad bridge and then the Interstate Bridge were opened early in the 20th century, the city was able to grow. The Interstate Bridge opened in 1917, and just in time, it would seem, because the United States entered World War I only two months later. Thousands of people came to Vancouver from across the nation to work at the shipyards, or to join the Spruce Production Division turning out wood for airplanes. After the war, most left, and the town languished.

Nothing changed the face of the city as much as World War II. The Kaiser Company built a large shipyard on Ryans Point. Alcoa Aluminum opened just after Bonneville Dam brought cheap hydroelectric power. The ranks of soldiers at the Barracks swelled. Thousands of people arrived, and the population grew daily. The city had been almost entirely Caucasian, with a scattering of Native Americans, some Japanese farmers, and just one African American. That would change dramatically during the 1940s.

Construction of the Interstate Highway System in the 1950s once again divided the city, as the freeway sliced a canyon between downtown and the Barracks. A second bridge across the river was needed. After months of study, the new bridge was placed next to the old.

In the 1980s the river again was crossed, this time to the east. The Glenn Jackson Bridge, connecting Interstate 205, opened in 1982 and brought yet another building boom, bringing metropolitan Portland within reach. Stretches of farmland grew houses and shopping centers instead of crops, and the population again surged. Annexations of former cropland made Vancouver the fourth largest city in Washington, leaving the small settlement of the 1820s as a distant memory.

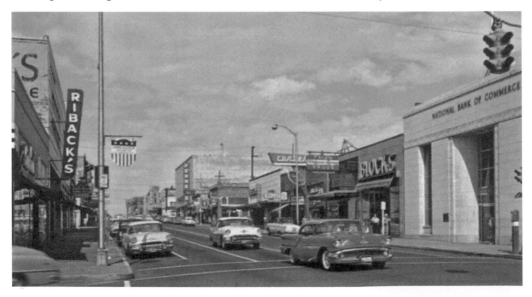

Main Street
This view looking north from Eighth Street shows Main Street in its days as a retail center. Shopping malls had not yet come into widespread existence, and several department stores and specialty shops line the sidewalks. On the light pole upper left, Vancouver proudly displays its "All-America City" award, presented by *Look* magazine in 1958. (Greater Vancouver Chamber of Commerce.)

CHAPTER ONE

From British to American

Because both the United States and Britain claimed the Pacific Northwest, an unusual mix of people settled in what would become the Vancouver, Washington, area. Each exploration, place naming, or settlement meant a new foothold for either the Americans or the British. The settlement of the fort by the British-Canadians provided a class system—gentlemen within the fort's palisades, and workers without—and also a mixture of nationalities: French, Hawaiian, Native Americans, and citizens of the burgeoning British Empire. The company encouraged marriages between the gentlemen and workers of the fort and the local Chinook and Klickitat women, in the belief that this brought stability to the frontier. Many of these original workers stayed behind as the political rule shifted and the United States took the reins. The Hudson's Bay Company had been the de facto government and the law, but that role now shifted to the US Army. Many military men found the area attractive and stayed on after their enlistments ended.

Although intrepid settlers had found their way to the north bank of the Columbia River before the Treaty of 1846, that document opened the floodgates. The Oregon Trail had several termini, and Vancouver was one of those. Conditions in the eastern part of the continent and political and economic upheaval in Europe encouraged emigration and brought added diversity to the mix. The wars of the 19th century solidified the influence of the Army on the community. Churches, lodges, and businesses grew out of the ranks of the Barracks. Children of soldiers married children of the original settlers and raised families of their own. Sutlers became merchants, chaplains became pastors, and officers became professional men. The fates of the city and the Barracks were inextricably intertwined and would remain so for years to come.

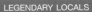

Capt. George Vancouver, City Namesake
Captain Vancouver hailed from Kings Lynn, England. His father signed him on as an able-bodied seaman at 14. As captain, he charted the west coast of North America, earning a reputation as a hard taskmaster; his charts were so exact that they were used until the 1930s. He retired after that mission, but lived just a short time, dying at 41. (National Park Service.)

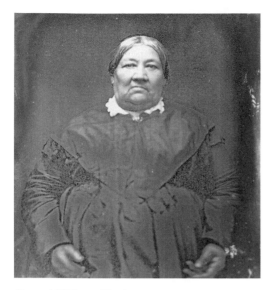

Margaret McKay McLoughlin, Mentor
Margaret McKay was a widow with three children when she met and married John McLoughlin, who already had one son, John Jr. Together they would have four additional children. She took on the role of mentor and guide for the young Native American women who married gentlemen of the Hudson's Bay Company, teaching them European ways. Dr. McLoughlin doted on her and quickly responded to any slight. (National Park Service.)

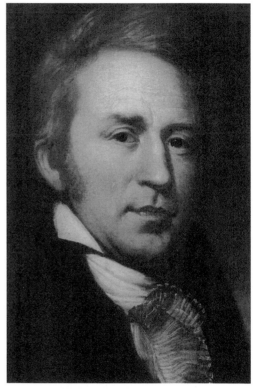

Capt. William Clark
Meriwether Lewis knew William Clark as a staunch and brave soldier and chose him to be his co-captain of the Corps of Discovery. After the transcontinental trek, Clark was appointed governor of the Territory of Missouri. He named his first son Meriwether Lewis Clark and arranged for Sacagawea's son, Baptiste, to receive an education. While the explorers were in Clark County, Meriwether Lewis was ill, so Clark took over the journals. He was not the skilled writer that Lewis was, so his entries were quite terse. (National Park Service.)

Dr. John McLoughlin
While Dr. McLoughlin became known as "the Father of Oregon," to the Chinook he was "White Headed Eagle" for his fairness in dealing with them. He set a price for goods that was the same whether they were the first sold or the last. He endeared himself to American settlers by extending them credit, but when the Hudson's Bay Company demanded repayment, his popularity ceased. The territory passed laws denying him land he had purchased. He died in Oregon City in 1857. (National Park Service.)

11

William and Mary Kaulehelehe, Hawaiian Residents of the Fort
Referred to as "Kanaka William," William Kaulehelehe was sent by the Hudson's Bay Company to be a spiritual guide for the hundreds of Hawaiians the company employed. Some workers thought that he could be a go-between for airing their complaints about the company; others were not so welcoming, not wanting to give up their only day off, Sunday, to hear his sermons. He returned to Hawaii once, in 1845, only to find that his land had been taken for a plantation. He returned to set up an Owyhee Church in the fort. He and his wife, Mary Kani, were permitted to live within the walls of the fort, the only Hawaiians so distinguished. When the company moved to Fort Victoria, the Kaulehelehes stayed behind at the fort until it and their home were burned. They then followed the company to Fort Victoria, where William worked as a clerk and translator. (Royal British Canadian Museum.)

Sir James Douglas, Father of British Columbia

James Douglas was born in Demerara, in what is today Guyana, to a Scots father and a Creole mother, Marie Tefler. She was termed a "free Coloured," which meant a person of European and African descent. He came to Fort Vancouver at the urging of Dr. John McLoughlin. There was no one that McLoughlin trusted more, and when the doctor and Margaret decided to renew their marriage vows, Douglas performed the ceremony under his title of justice of the peace. When the doctor retired to Oregon City, Douglas and Peter Skene Ogden shared chief factor's duties until the fort relocated. Douglas then became chief factor in Fort Victoria and, when gold was discovered on the Fraser River, he extended his authority to the mainland to prevent American occupation. He earned the title "Father of British Columbia." (National Park Service.)

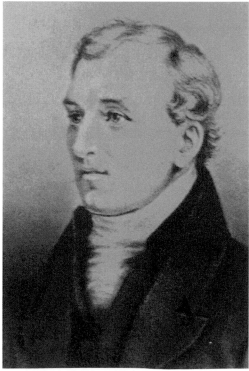

David Douglas, Botanist

The brilliant young Englishman arrived at Fort Vancouver before it was finished. There was no place for him to stay, so he built a hut of tree bark. Eventually he filled it with his specimens and, when the torrential cold winter rains arrived, his miserable little hut virtually dissolved. He moved into the factor's house (pictured). That wasn't finished either and would not be truly finished for years. He made detailed studies of the plants of the Pacific Northwest and is best remembered today as the namesake of the Douglas fir. (Left, National Park Service; below, Library of Congress.)

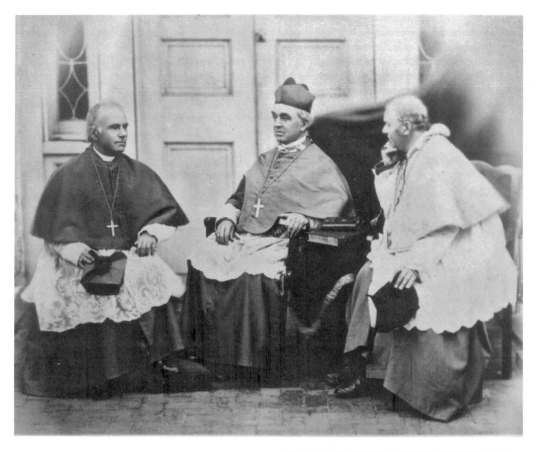

Father Demers and The Fathers Blanchet
Father Francois Blanchet arrived in the Oregon Country in 1838, along with Father Modeste Demers. Services were held in whatever room or structure was available, often sharing space with Protestant missionaries, an arrangement that neither party found pleasant. Father Blanchet built a small church, St. James, just north of the fort of the Hudson's Bay Company. He was part of the assemblage at Champoeg framing Oregon's first government. Father Demers devoted himself to missionary work with the Chinook. He learned their language, and eventually wrote a dictionary and several hymns in Chinook. Augustine Magloire Blanchet followed his brother both in the priesthood and in the mission to St. James. When he was made bishop, he named the little church his cathedral. He was buried inside the new St. James Church on 13th Street (pictured), but when the archdiocese moved to Seattle his remains were moved there. (Top, National Park Service; bottom, Greater Vancouver Chamber of Commerce.)

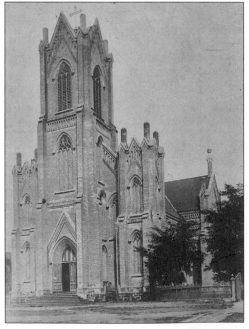

Naukane, "Old Coxe"

A courtier in the Royal Court of Kamehmeha II, he travelled to London to visit King George IV. Just two weeks into the visit, measles struck. The king and several others died, and when the party returned to Hawaii, the survivors were regarded with suspicion. He fled to Fort Vancouver where he became a "rower." His name was unpronounceable to the gentlemen, so he became Old Coxe or John Coxe. When western artist Paul Kane visited the fort on his journey across the continent painting Native Americans, he painted Naukane's portrait. Naukane told Kane that he had been present when Captain Cook was eaten in 1747; Kane dutifully reported Naukane's comment, although the authenticity of Naukane's claim is certainly in doubt. (National Park Service.)

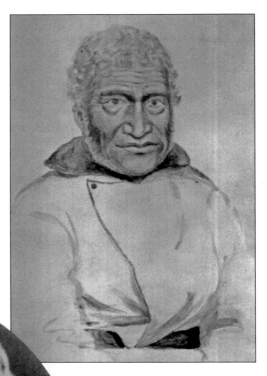

Peter Skene Ogden, Negotiator

Peter Ogden could be violent. When he was a Northwest Company man, he killed an Indian who traded with the Hudson's Bay Company. When the HBC ended competition by buying all other fur companies, Ogden presented a problem: What to do with him? Ultimately, they decided that he was no worse than anyone else in the trade. In spite of his early ruthless reputation, he became a skilled negotiator, settling Indian disputes, advising on the Treaty of 1846, and eventually arbitrating the settlement of the US Army's contract with the HBC. (National Park Service.)

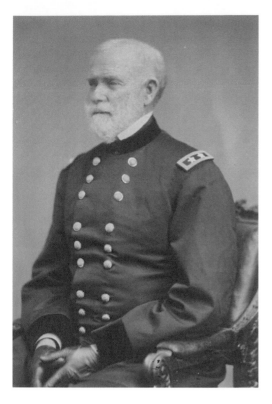

Gen. William Selby Harney

One would not expect a commander of Vancouver Barracks to start a war, but General Harney did just that in 1859. The Treaty of 1846 had left vague the ownership of San Juan Island, and both sides attempted to settle and to tax the settlers. The competition peaked when an American farmer shot a British farmer's pig that he found rooting in his vegetables. Harney, on his own, sent troops to "protect Americans," thus inciting the so-called Pig War. Winfield Scott, hastily sent from Washington, DC, and Sir James Douglas worked out an amicable solution, sparing the United States another war with England. (Library of Congress.)

Gen. Philip Sheridan

He was a small man, topping out at 5'5", but a fierce soldier. His hot temper got him suspended from West Point for one year, and he barely escaped having enough demerits for summary dismissal. But he made it through and was posted to Vancouver in 1855. When the First Nations attacked the settlement near the Cascades in 1856, Phil Sheridan led the detachment from Vancouver Barracks to put down the outbreak. He loaded the soldiers onto the *Belle*, captained by William Troup, which served as supply and ammunition ship. But the First Nations melted into the forest and escaped. Sheridan went on to play a prominent role in the Civil War. (Library of Congress.)

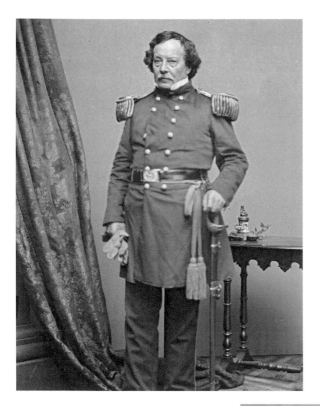

Gen. Benjamin Bonneville
Born in Paris, he was the godson of Thomas Paine. He graduated from the Military Academy at West Point after only two years. The Grant House on Officer's Row should rightly be called the Bonneville House, for it was he who actually lived in the house when Grant was in Vancouver. It was ironic that Bonneville was assigned to Vancouver Barracks. During his leave of absence from the Army, celebrated in Washington Irving's book, *Colonel Bonneville*, he tried in vain to trade with the Hudson's Bay Company. John McLoughlin had warned his trappers and traders not to do business with him, and no one would. (Library of Congress.)

Gen. Rufus Ingalls
Ingalls studied at West Point with Ulysses S. Grant, graduating in 1843. He and Grant fought together in the Mexican War. He was appointed quartermaster in 1848 and served in that role for the rest of his career. As a captain, he came to Vancouver Barracks and lived in "Quartermaster Ranch" (pictured) with Grant and Captain Stevens. In the Civil War, he was assigned to Florida, and then transferred to Virginia, where he was aide-de-camp to General McClellan. In 1864, Grant placed him in charge of supplies for all armies fighting in Richmond and Petersburg. After the war, Grant appointed him quartermaster general with the rank of brigadier general. (Library of Congress.)

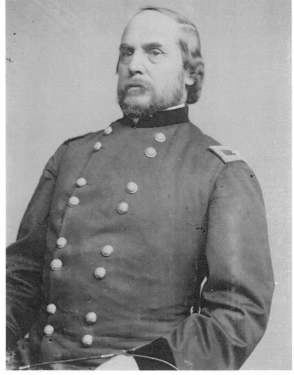

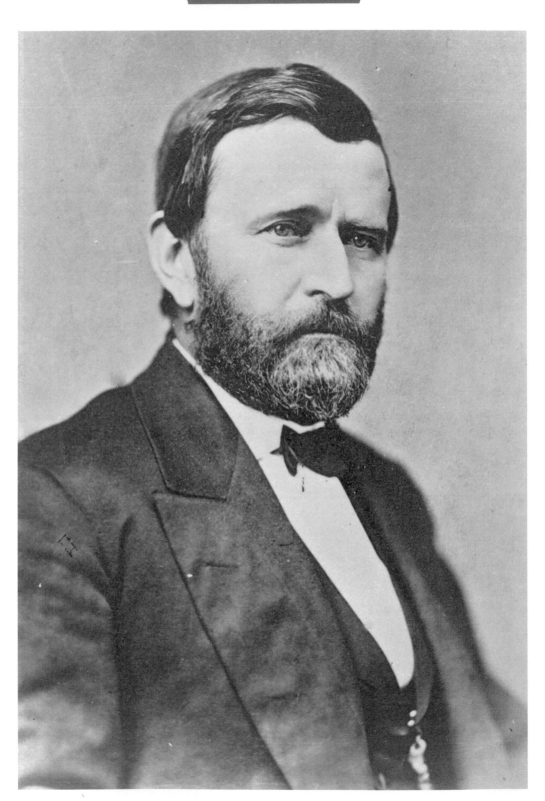

Ulysses S. Grant, Teetotaler (LEFT)

When Grant arrived at Vancouver Barracks, he was a teetotaler; in fact, he was master of a lodge called the Sons of Temperance. He was almost unbearably lonely in Vancouver. When he would receive a rare letter from his wife Julia, he would get drunk, and then promise not to do it again. He wouldn't, until the next letter. He wrote to Julia that "a gentleman farmer can make a pleasant living" in the area. He tried many ways to raise enough money to bring his family to him. He tried cutting ice for San Francisco, and he tried trading chickens. The ice melted; the chickens died. He tried growing potatoes; the river flooded and swept away his crop. He and the other quartermasters had sleigh rides, staged horse races, and held soirees for their friends. He visited with families, seeking that warm home atmosphere that he missed. When he was transferred to Benicia Barracks, it was too much. He resigned from the Army and headed home to Julia. He was out of the Army for 10 years and then when the Civil War began, he raised volunteers, was elected their colonel, and went off to war. How different the course of that war might have been had he been able to settle in Vancouver. (Library of Congress.)

Esther Short, Vancouver's Best-Known Woman

Probably the best-known woman in Vancouver's history, Esther Short emigrated from Pennsylvania with her husband Amos. They jumped the claim of Henry Williamson and built a cabin for their large family. They resisted every effort of the Hudson's Bay Company to dislodge them from Williamson's claim, finally resorting to gunfire. Amos shot David Gardner, a fort employee, but was cleared of the charges. He was lost at sea returning from a trip to San Francisco, and Esther declared herself the heiress to the land claim. Then she learned that Amos had not registered it. She filed her paperwork and continued with a hopelessly clouded title. She divided the claim in half, giving the western half to her children, and selling some of the lots in her half. She further complicated the ownership questions with her will, in which she left a section to be a public plaza. Today it is called Esther Short Park, pictured with the George Propstra Tower. She left the waterfront to the city to be a public wharf, called the Inn at the Quay today, or Berth One of the Port of Vancouver, and then she left the rest to her daughter Hanna, who was confined to a wheelchair. The other nine children sued and successfully challenged the will, which further complicated land titles. It would take almost 50 years to settle all title questions. (above left, *Vancouver Columbian*; above right, City of Vancouver.)

Henry Weinhard, Brewer

The lure of good water wells lured brewers to Vancouver. One of them was Henry Weinhard. He emigrated from Germany and worked at several breweries developing his own recipes. He came to Vancouver and went to work at Muenich's Brewery. He left to start his own, but it didn't grow fast enough for him. He returned to Muenich and soon bought him out and renamed the business Vancouver Brewery. After a few years, he sold that brewery and moved his family to Portland. At the opening of Skidmore Fountain, he offered to run a hose from his largest vat to allow the fountain to flow beer on its first day of operation. (Stein Distributing Company, Vancouver.)

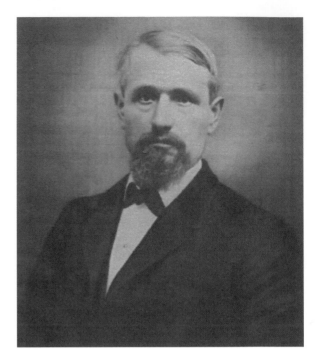

Christian "Henry" Christ, Shoemaker

As a youth in Germany, Christ learned the shoemakers' trade, a craft that offered good employment anywhere. The young city of Vancouver presented an opportunity. Rapidly growing prosperous, he built a commercial building in downtown that he dubbed "Christ's Block." His contributions to the community grew to the point that he was elected county commissioner. In that office, he saw that what the city and county needed was a solid courthouse. He not only voted for the necessary funds, but he picked up tools and helped to build it. (Vancouver Masonic Center.)

Mayor Louis Sohns
A true Prussian, Louis Sohns had been a student at the University of Heidelberg when the emperor instituted a military draft. The students rebelled and the army moved in. Sohns fled to America posing as an English teacher. Upon arrival he promptly joined the US Army as a musician and travelled west with Ulysses S. Grant. When his enlistment was up, he remained in Vancouver. He had several successful businesses and invested in the first telephone company. When U.S. Grant returned in 1879, Sohns met him at the wharf as the city's mayor. He was elected to the Legislature and served on the Constitutional Convention in 1889 when Washington was admitted to the Union. (Vancouver Masonic Center.)

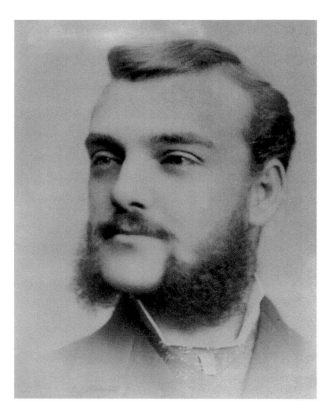

Capt. William Troup
Captain Troup was a Londoner. He trained as an engineer and took a job in Chile, and then never looked back. He sailored up and down the west coasts of the Americas before settling in Vancouver. He launched the riverboat *Belle* and worked on the river. He and the *Belle* transported Phil Sheridan and his troops to the Cascades to put down the First Nations uprising. A disastrous fire destroyed much of Vancouver in 1866, so a volunteer fire department formed, and Troup was elected chief. When he died in 1888 after a two-day illness, the entire fire department turned out for the funeral. (Vancouver Masonic Center.)

21

John McCarty, Chaplain

As chaplain at Vancouver Barracks, McCarty was loved by the soldiers who called him "bishop" or the "fighting parson" because of his actions on the battlefield. He would say, "This is an unholy war, but keep your powder dry." During the same time period that he was at Vancouver, he was chaplain at Fort Steilacoom, starting a church at Olympia, and beginning St. Luke's Episcopal Church in Vancouver (pictured). Traveling back and forth between the two churches, one night he lost his way in the wilderness. As night fell, he found a burned-out log and crawled inside for shelter. He continued on the next day, dirty but determined. (Left, Library of Congress; below, St. Luke's Episcopal Church.)

Rev. Albert Scott Nicholson

When John McCarty left the congregation, they called Reverend Nicholson, a former chaplain, to succeed him. He accepted their offer, and he and his wife arrived on the steamboat *Oriflame* on June 28, 1868. He began a newspaper, the *Churchman,* and served as editor/publisher. He was one of the partners who began the *Vancouver Independent* newspaper. He moved on to Tacoma in 1886, where he added the duties of superintendent of the Tacoma Hospital to his duties as pastor. (Vancouver Masonic Center.)

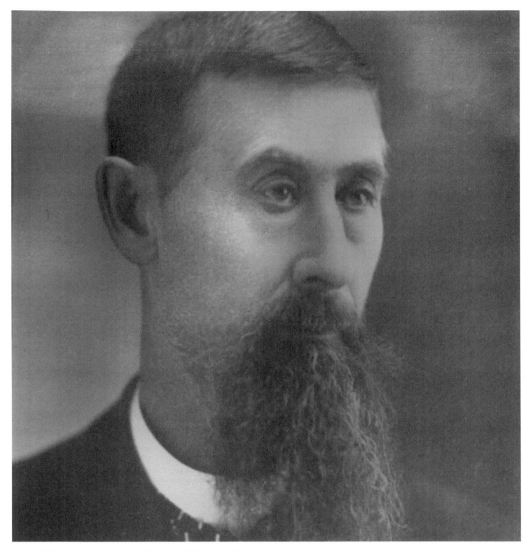

Lowell Mason Hidden, First Hidden in Vancouver
The first of the Hidden family to arrive in Vancouver, Lowell had travelled across the continent to seek his fortune. He landed in California. He was sent to Vancouver by an employer in San Francisco to bring in a crop of hay. However, the Columbia River had flooded and inundated the crop. He then worked at a variety of jobs until he saved enough money to buy a parcel of wooded land. He promptly cut the timber and sold it to steamboats. He then sold off five acres. Other ventures followed; he owned farms and hotels. He planted an early prune orchard at Main Street and Fourth Plain Road. There was a Hidden washing machine company and a mill. He started the Hidden Brick Company in 1871; it is said that he was urged to do that by Mother Joseph so that she would have bricks for the Academy. The brickyard was on Main and 15th Streets. In 1908, he donated part of that yard to the city to become the Carnegie Library. His bricks built St. James Church, the library, St. Joseph's Hospital, and numerous other structures. He was a city councilman for eight years, and a county commissioner for two. There was a saying that you could never find a building in Vancouver because the bricks were always Hidden. The brick company is no more, but the distinctive bricks stamped with the name Hidden are prized throughout the county. (Vancouver Masonic Center.)

23

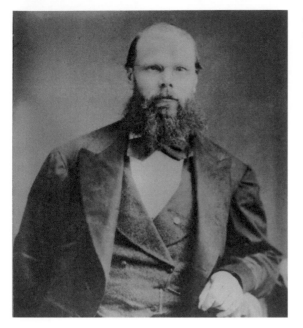

Joseph Fletcher, Attorney

Joseph Fletcher was a pillar of the community. He had been the senior warden of St. Luke's Church when it incorporated in 1868, and master of the Masonic Lodge in 1869, 1876, and 1877. On March 14, 1882, he walked down Main Street toward the river. He stopped and chatted with friends and acquaintances and then disappeared. Searches produced no information. The river was dragged. Even the firing of cannons over the water, known to cause bodies to surface, had no effect. The Masonic Lodge offered a princely $60 reward for information. Finally, weeks later, his remains were found not in the Columbia, but in the waters of the Lewis River. What happened, and how he came to be there, has never been discovered. (Vancouver Masonic Center.)

George Washington Durgin, Fire Brigade Founder

Somewhere on the trail west, Durgans's name changed to Durgin. He became a successful businessman, but, just after he built a handsome new building downtown, in 1866, a conflagration destroyed his building along with many others. His answer was to form a fire brigade that developed into the City Fire Department (pictured). Twice he was elected sheriff, once in 1867, then in 1871. Not content to rest, he was county treasurer, director of schools, a deputy revenue collector, and a deputy marshal. He served on the board of St. Joseph's Hospital, and to preserve the hospital set up a subscription list that was almost the equivalent of health insurance. (Below left, Vancouver Masonic Center; below right, Hale Family collection.)

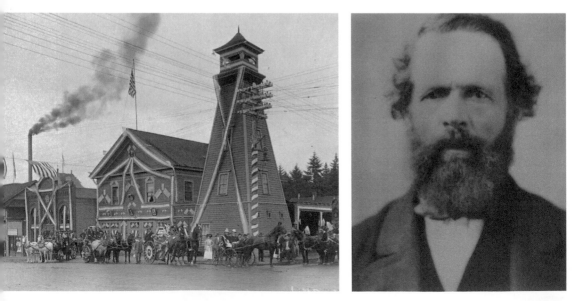

John McNeil Eddings, Government Employee

John was born in Ireland. His family came to America when he was just 11. He joined the US Army and was sent to Vancouver Barracks in 1851. There he became a good friend to U.S. Grant and Rufus Ingalls, both quartermasters. Ingalls appointed him storekeeper. To augment his military pay, he became Vancouver's postmaster. He worked for the government for 30 years, and in that time, he took but one leave. He wanted to see Ireland, but only made it as far as Michigan before turning around to come back to work. (Vancouver Masonic Center.)

William Eddings, City Treasurer

When his father, John Eddings, was postmaster, William was assistant for 11 years, then worked in Vancouver Barracks as a storekeeper as his father had been. He followed John into the Masonic Lodge, and as had John, was master. In 1890 he was elected as Vancouver city treasurer but soon became ill. He continued to work as his health failed. At last, when only 35, he collapsed and died from a brain tumor. (Vancouver Masonic Center.)

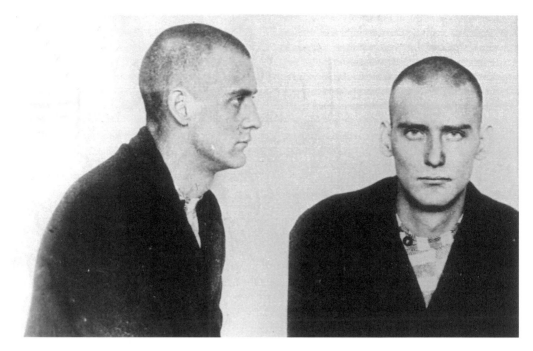

David Merrill, Outlaw

Half of the outlaw team of Tracy and Merrill, he was known in Vancouver as David Robinson. An uncontrollable boy, he was in and out of the town jail. When he escaped from the jail in 1887, the town threw up their collective hands. "His parents have done all they can," the *Vancouver Independent* lamented. He was soon arrested in Portland for stealing a suit of clothes. His sister, Mollie, married Harry Tracy, who was worse than her brother. He was suspected of at least 10 murders. Tracy and David joined forces and committed robberies across the Northwest until they were sent to prison in Salem, Oregon. They escaped, killing another inmate and two guards. At gunpoint, they forced a trio of men to row them across the river to Lieser's Point. The robbery of a farmer on the Fourth Plain Road was their next crime, setting off the biggest manhunt in local history. They continued north, robbing and stealing until they reached Napavine. A quarrel erupted that ended in a duel. Merrill fell dead. Near Creston, surrounded, Tracy shot himself in the head. (*Vancouver Columbian.*)

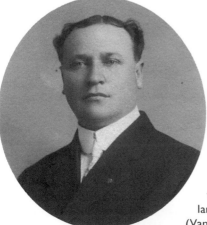

Joseph "Dode" Carter, Telegrapher

The center of gossip and conversation in the 1890s was the telegraph office. All news came by wire. Dode Carter was Vancouver's telegrapher with an office on Main Street. He soon added tobacco and then a billiards hall. The Portland Athletic Club, of which he was an active member, staged boxing matches both in Portland and at his brother-in-law, Otis Smith's, stable. His next venture was a jewelry store, at 5th and Main Streets. He became an Elk, and served as exalted ruler. A run for office was next, and he was elected to the Vancouver City Council. He donated the land for a park to the city, and it was named "Carter Park." (Vancouver Elks Lodge No. 823.)

Rev. Thomas May

Reverend May was the first minister of the First Presbyterian Church. He arrived November 30, 1882. The congregation met in various halls and lodge rooms around the city until a church could be built. They bought a lot at what is today Evergreen and Daniels and made plans to build a fine brick church. The church was completed in the spring of 1885, a charming white frame structure with a graceful 100-foot spire. Somewhere in the planning, the brick became lumber. Around the same time, May was reassigned to Seattle. The congregation sent a pleading letter to the Home Mission Board, and May stayed on. The congregation grew from 15 members to over 100 by the time he left. (Left and below, First Presbyterian Church.)

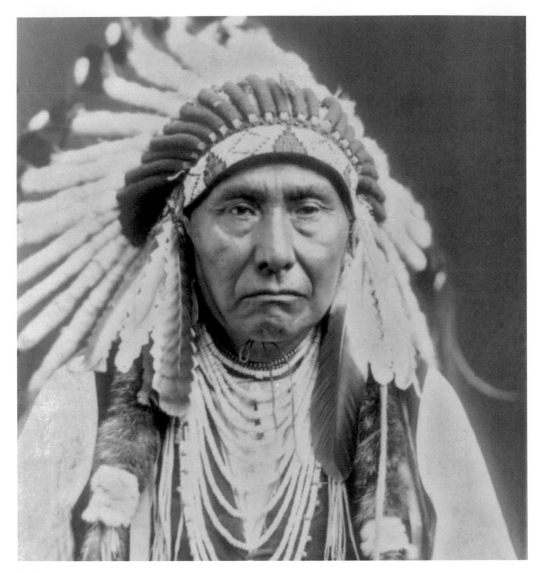

Chief Joseph

When he was known as Young Joseph, he promised his dying father that he'd never sell his ancestor's graves. Old Joseph had signed a treaty giving the tribe a huge reservation that stretched from Washington to Oregon and Idaho. When gold was discovered on the land, the government took back six million acres. Joseph the Elder renounced his citizenship and refused to move to the smaller reservation.

In Idaho, Joseph the Younger followed his father as chief and followed his wishes. When Gen. Oliver Otis Howard threatened to attack and force the Nez Perce onto the reservation, it set in motion events that culminated in a 1,400-mile strategic retreat that inspired respect in every soldier who fought Joseph. He almost made it into Canada. Short of the border he grew heartsick. The death and destruction of his people cut his soul. At last he said, as chronicled by C.E.S. Wood, "I am tired of fighting. Our chiefs are dead. . . . My heart is sick and sad. From where the sun now stands, I will fight no more forever." His people were moved from reservation to reservation. C.E.S. Wood sent his young son to live with the chief for two summers. Joseph died, exiled from his home, some said of a broken heart. (Library of Congress.)

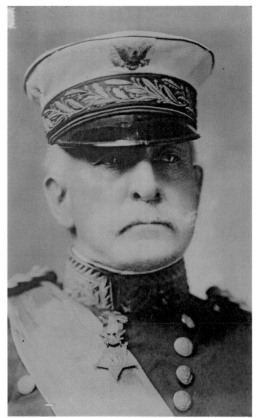

Gen. Nelson Miles

Miles fought valiantly in the Civil War, was wounded four times, and received the Congressional Medal of Honor. In the winter of 1877, he intercepted the Nez Perce band led by Chief Joseph. He quarreled with Gen. O.O. Howard over credit for the capture, a quarrel that would continue for the rest of his life. At the Barracks, he had the Nez Perce prisoners plant the trees that now line Officer's Row (pictured). Miles captured Puerto Rico during the Spanish-American War. Not wanting reporters at the scene of the battle, he misled journalists as to his plans, telling them that he would attack from the south, even as he invaded from the north. Later he was the military governor of Puerto Rico. (Left, Library of Congress; above, Greater Vancouver Chamber of Commerce.)

Oliver Otis Howard, Soldier

Howard was a moral crusader as much as a soldier. He was ready to leave the Army and become a minister when the Civil War began. He lost his right arm at the Battle of Fair Oaks. Lincoln appointed him as head of the Freedman's Bureau, to solve the problem presented by thousands of freed slaves. Seeing that the answer lay in education, he helped found an all-black college now known as Howard University. Sent to Vancouver, he was charged with forcing the Nez Perce onto a reservation. Chief Joseph would not sign away his homeland, and events escalated into the Nez Perce war. (National Park Service.)

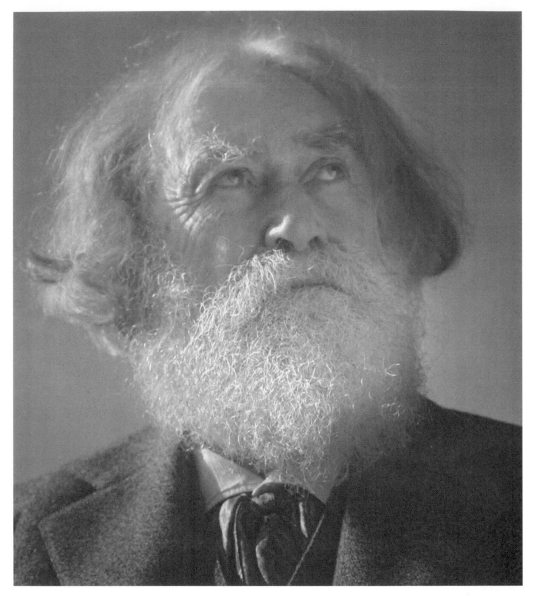

Charles Erskine Scott Wood, Soldier
Wood lived intensely and extravagantly. He was a soldier, attorney, poet, lawyer, and raconteur. He graduated from West Point and then was assigned to Vancouver Barracks. He was O.O. Howard's aide-de-camp during the pursuit of Chief Joseph and the Nez Perce. It was he who wrote the stirring words attributed to Chief Joseph that end "I will fight no more forever." He sent his young son, Erskine, to stay for two summers with Chief Joseph and learn the ways of the Nez Perce. He left the Army, moved to Portland, and became a successful attorney. Wood fought for the radicals of his day, such as Margaret Sanger and Emma Goldman, yet defended corporate clients. He prized art and literature and gave the Skidmore Fountain to Portland. He fell in love with Sara Field Erghott and lived openly with her for decades while still keeping his marriage to Nanny Wood. The home that he built for Sara in Los Gatos, California, was a magnet for the famous of the day. Actors, artists, musicians, and authors all found their way between the pair of sculptured cats. (Wood Family collection.)

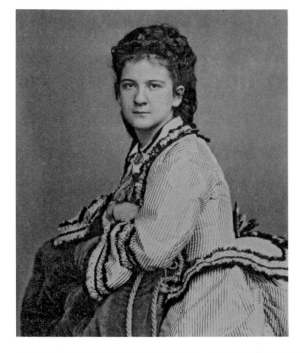

Nanny Wood, Belle

Nanny's parents died while she was a child, and she was raised by her father's cousin. He sent Nanny to an expensive school, where she learned to be a Southern belle. She met Charles Erskine Scott Wood while he was a heart-meltingly handsome West Point cadet. They married in 1878 and came to Vancouver Barracks. Her parties became the talk of the Barracks for their sophistication. His serial philandering began almost at once. She chose to ignore it. She continued to ignore it even when he left her for his mistress, moved to California, and built a luxurious home for the two of them. Nanny remained faithful and silent, and became the doyenne of Portland society. After her death, her son, Erskine, donated her home to the Portland Garden Club. (Wood Family collection.)

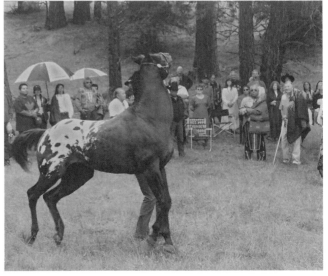

Erskine Scott Wood, Attorney and Businessman

The son of C.E.S. Wood, Erskine went to stay with Chief Joseph for two summers. He asked Chief Joseph what he would most want that his father could give him. Joseph replied, "A fine stallion." Erskine did not think that a fine enough gift, so he forgot about it until he was grown, when he realized how much a stallion meant to improving the herd of the Nez Perce horses. Although he had a successful life as an attorney and businessman, the failure to keep that promise was the major regret of his life. One hundred years later, his family contributed the money, and Erskine's family scoured the globe for the perfect stallion. In 1997, a magnificent Appaloosa Stallion (pictured) was presented to the Nez Perce, fulfilling that long ago pledge. (Above left and right, Wood Family collection.)

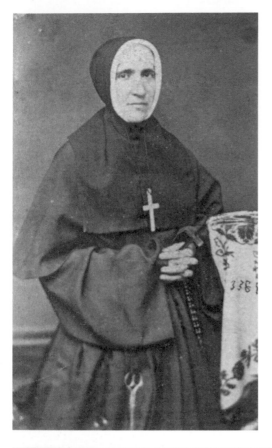

Mother Joseph, Builder

Esther Pariseau of Saint Elzear, Quebec, was the third of 12 children. Her father, Joseph, taught her carpentry and building. Her mother taught her embroidery and other domestic skills. The many other skills she possessed she taught herself. At 20, she entered the convent of the Sisters of Charity and took the name Joseph to honor her father. Bishop Blanchet asked for assistance, and the mother house sent Sister Joseph and five nuns to Vancouver. There was no place for them to stay, so they swept out a vacant Hudson's Bay house and moved in. The first thing she saw that the town needed was a good insane asylum, and she opened the Sisters of Providence Lunatic Asylum. There soon followed a hospital, and the Academy, a combination orphanage and school (pictured). She designed it, and, when finished, it was the largest brick building north of San Francisco. She financed all of her works through begging. In the end, she had built academies and hospitals throughout the Pacific Northwest. In 1902, she died from a brain tumor. Her last words were, "Remember sisters, whatever we do, we do for the poor." Her statue stands in the Capitol in Washington, DC, as a representative of the best of our state. (Left, Archives Seattle Archdiocese; below, Library of Congress.)

Sgt. Moses Williams

A son of slaves, Moses Williams was born in 1845 in Carrolltown, Louisiana, a settlement near New Orleans. When he joined the US Army in 1866, he signed his enlistment papers with an *x*. Four years later, when he reenlisted, he signed his name. Little is known of his early life, but he was promoted to sergeant almost immediately. At a battle in the Cuchillo Negro foothills in New Mexico, on August 16th, 1881, Sergeant Williams distinguished himself in battle to the extent that he was nominated for, and received, the Congressional Medal of Honor. His final assignment in his 37-year career was command of the military personnel at Fort Stevens, Oregon, during its reconstruction. This was an incredible assignment for a non-commissioned officer, much less a black soldier, at that time. He moved on to Vancouver Barracks, where he requested a discharge due to ill health. It was granted, and he settled into a small house just outside the Barracks, where, in August 1899, he was found dead in his bed. Before he was laid to rest in the Post Cemetery, the chaplain placed upon the old soldier's breast his sharpshooter's medal and the Congressional Medal of Honor. (Army Museum, Fort Bliss, Texas.)

Gen. Thomas Anderson

The longest serving commander of the Barracks, Anderson was also the first general to lead American troops into battle in Asia. He was sent to the Philippines, where Admiral Dewey had blockaded Manila Bay. On the way, the ships sailed into Apia Bay in Guam, which was Spanish territory. A round was fired into the fort, and silence ensued. Then the harbormaster's rowboat appeared and, as he was lifted onto the ship, thanked the captain for his salute, and asked to borrow powder with which to return it. Thus was Guam captured. In Manila, the Filipino and Spanish soldiers fought valiantly for 45 minutes before the prearranged surrender. Only later did they discover that the war had ended the day before. The Hop Gold Brewery in Vancouver immediately sent off 300 cases of beer to Manila. Emilio Aguinaldo's Philippine insurrection kept Anderson and his troops for two additional years. General Anderson was a small man, barely 5'5", but his voice could be heard across the parade ground. His troops called him "the Little Orator." He formed an acting troupe while in Vancouver that staged many entertainments for the city. He retired to Portland. (Library of Congress.)

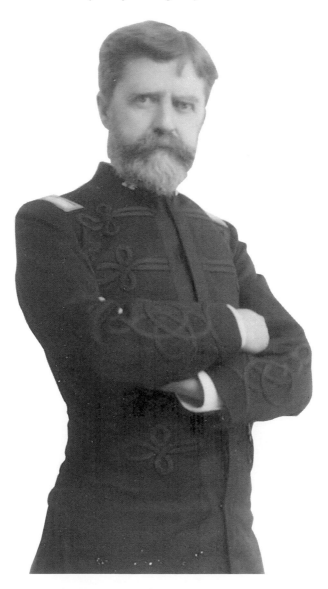

John Beeson, Newspaperman

John Beeson was the son of a newspaper owner and learned the trade at his father's knee. He became the editor/publisher of the *Independent Newspaper* in Vancouver in 1876. A cultured man, he had an extensive library, and was a musician and a keen Freemason. When his wife began a lawsuit to obtain a family inheritance, he mortgaged everything he owned to pay for her legal fees. When the settlement came in, she took the money, moved to California, and divorced him. Everything he had was lost; he lived out his life supported by a daughter. (Vancouver Masonic Center.)

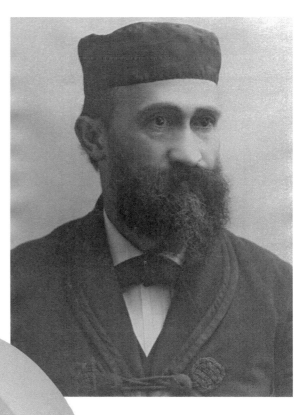

Rev. John Thompson

Described as "impatient, vigorous, an organizer," who "made rapid decisions," his innovations took his congregation at the First Presbyterian Church aback even as they moved forward. He was a bachelor and made his home in a storeroom at the back of the church instead of in the manse. He organized schools, and 21 churches, including St. Johns in Camas. The Methodists in Vancouver did not have a church building, so Thompson offered to let them use his, their respective congregations attending both services, as he said "to dwell together in unity." (First Presbyterian Church.)

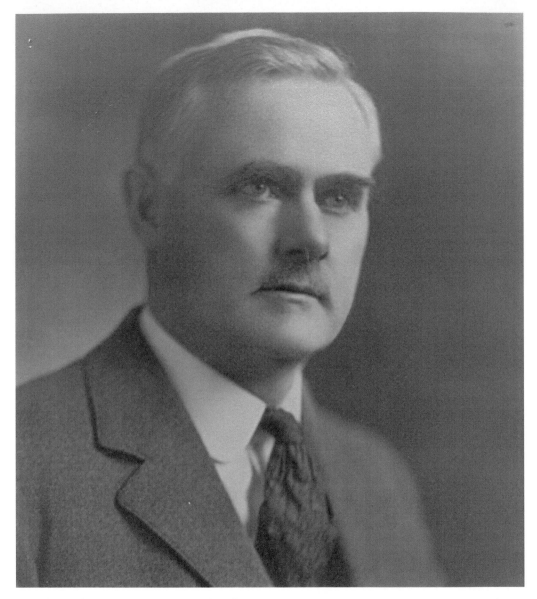

Abraham Lincoln Miller, Prosecuting Attorney

If ever a city's heart could break, it broke when Abe Miller was found dead at the wheel of his car in Portland. He was found by a streetcar motorman who found the tracks blocked by Miller's heavy car. A crumpled fender indicated that an accident had caused a heart attack. His son, "Hap" Miller, was the exalted ruler of the Vancouver Elks Lodge and was conducting a meeting at the time his father's car was discovered. He wouldn't leave the meeting to take the phone call notifying him of the death, so they kept the line open until the meeting was over. Abe had been prosecuting attorney for both Klickitat and Clark Counties when there was not enough crime in either county to justify a full-time position. He became a judge of the Superior Court in Clark County at 32, the youngest ever to wear the robes. At the same time, he was the grand master of Masons in Washington State. He also opened a law firm with Charles Hall and Donald McMasters that was rapidly successful, and they were part of the organization that started Vancouver's first telephone company. (Vancouver Masonic Center.)

CHAPTER TWO

First Boom and Bust

The 19th century had ended with the war with Spain; it began with the Philippine Insurrection and marked the end of the Victorian era and the dawn of the modern world. The bicycle appeared on the streets, soon followed by automobiles, and then by a streetcar system.

New businesses that served those advances entered the city. Businessmen pushed for more modern advances: the telegraph, telephones, and more modern transportation. The ferryboat that connected Vancouver and Portland was proven to be outmoded when the Lewis and Clark Exposition of 1905 led to more traffic than it could handle. A demand for better transportation was partially met when the Railroad Bridge was constructed along with a rail line on the north bank of the river.

With that link came a rush to build libraries, churches, and schools. Craftsman-style houses began to appear. A streetcar line connected downtown Vancouver with Sifton. Shops sprang up along the line. Soon the clamor began for a wagon road bridge. That demand reached its climax when the two counties, Clark on the Washington side and Multnomah on the Oregon side, banded together and built the first Interstate Bridge in 1917. On the first day of the bridge, it was noted that automobiles had surprisingly outnumbered carriages.

World War I brought a boom that would only be eclipsed in World War II. Three shipyards grew on the west side of the bridge, and the Spruce Production Division with tens of thousands of men processing wood for airplanes sprawled to the east. The bubble burst with the armistice. The shipyards struggled for a couple of years, and the Spruce Division closed within days. Soldiers were mustered out. Prohibition shut the brewery. The businesses that had appeared on Main Street to serve the thousands of workers followed their customers out of town.

Prohibition would leave its mark, as would the Great Depression. The Northwest Headquarters of the Civilian Conservation Corps was at the Barracks, and they would build Lewisville Park and the fish hatchery, and the Public Works administration would furnish a new dock for the port. The city refashioned itself, unaware of the changes that were yet to come.

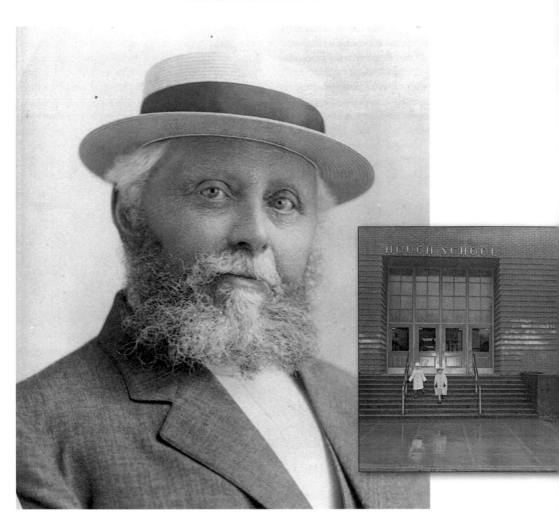

Patrick "Paddy" Hough, Teacher

The man for whom Hough School and the Hough neighborhood are named was born near Limerick, Ireland, on St. Patrick's Day, 1846. That year was the start of the Potato Famine, and he grew up amid great suffering, which influenced the rest of his life. When the Franco-Prussian War erupted, in 1870, he went off to France, where he became a stretcher bearer. During battle, he was wounded so badly that his left arm was lost. As soon as he recovered, he set out for Canada, where he began teaching at a parochial school in Westminster, British Columbia, which accepted boys of all races and creeds.

He accepted a job as head of Holy Angels College in Vancouver and taught there during the day, then taught night school training others to be teachers. He moved on to be principal at Columbia School on Kauffman Avenue. Paddy invested his salary wisely. He was an early investor in Ladd's Addition in Portland, as well as in Vancouver's telephone company, the *Columbian* newspaper, and in land. He later served as superintendent of schools. After he retired, his dress became noticeably poor and shabby. His friends noticed and became worried. It was not until his death, however, that his friends learned the reason for his seeming poverty. He had saved his money to bequeath it to the community. After small gifts to family and schools, the rest was to be used to establish an agricultural school in Clark County where students and faculty were to be accepted on merit only, not race or creed. Today the CASEE center of the Battle Ground Schools receives the fruits of Paddy's bequest. (Above left, Hough Foundation; above right, Clark County Genealogical Society.)

William Elliott Yates, Electable

Yates just could not help being elected. He moved from Oregon to Washington and back again. He was a mayor of Independence, Oregon, and of Corvallis. He was elected as superintendent of schools in Polk and Benton Counties. Then he became a prosecuting attorney and was elected in Oregon, then in Clark County, and then another term in Clark County. He joined several community organizations—the Elks, the Oddfellows, the Freemasons, Royal Arch, and the Knights of Pythias—and of course he was elected presiding officer in each of them. Before finally settling in Vancouver, he was the secretary of the Board of Regents for his alma mater, the Oregon Agricultural College. He was married, to Emma, with a son, Elbert, and a daughter, Elizabeth. He was, for many years, pointed to as a man to be admired, and, to be sure, a man to be emulated if one only had the energy. (Vancouver Masonic Center.)

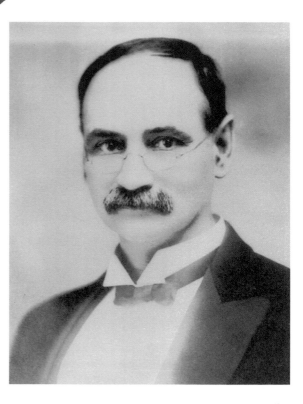

Edward Hixom, Physician

A gentle man, Hixom was born in Canada and became a naturalized US citizen, a standing he treasured. It was said that he was always the first one at the door of the polling place on Election Day. He was a doctor and advertised himself as an *accoucher*; today we would call him an obstetrician. He was devoted to the children of the community. He had long recognized the value of organization for physicians, and, with other doctors, formed the Clarke County Medical Association in 1906, and was elected as their first secretary. (Vancouver Masonic Center.)

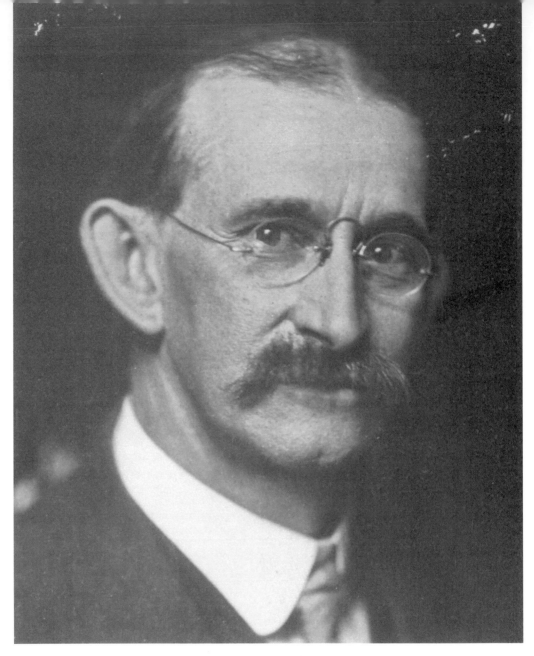

Thomas P. Clarke, Lobbyist for the Blind and Deaf

The State School for Defective Youth was founded in Vancouver in 1886. All disabled children were lumped together under that title, which was the 19th-century version of politically correct terminology. The developmentally disabled children were removed to Medical Lake in 1905. Clarke was the second director, taking over in 1906. He was appalled at what he found. The buildings were unsafe, the curricula inadequate. He lost no opportunity to lobby and work for blind and deaf children. He was a firm believer in work and physical education for the blind children, and they were taught weaving and chair caning. Clarke owned the first automobile in Vancouver and received the first parking ticket. He argued in court that the rules had been written for carriages, not cars, but the judge decreed that rules for horses applied to cars. Clarke would drive his car each day downtown, park in front of the courthouse, and ceremoniously run a rope from a horse ring to the hood ornament of the car. The ordinances were changed. (Washington State School for the Blind.)

Rev. Harry Templeton

Templeton and his wife drove across the continent in 1907 in their new Buick, a daring adventure then. When they arrived in Vancouver, they found that the First Presbyterian Church, built of wood with a grand spire, was in dire need of repairs. After much discussion amongst the congregation, money was allocated for that purpose. But in January 1911, before repairs could be made, the church was completely destroyed by a fire that started over the basement furnace. The fire was discovered at 7:45 p.m., and by 9:00 there was only a smoldering pile of ash. (First Presbyterian Church.)

Lincoln Beachey, Aeronaut

The Lewis and Clark Exhibition in Portland in 1905 was a wonderland of progress. One of the chief attractions was the exhibition of flight by Lincoln Beachey in the lighter-than-air craft Gelatine. Lincoln was only 18 on the day that he took off from the exhibition and suddenly veered northeast. Unbeknownst to the crowd, he was carrying a letter from the fair director, Theodore Hardee, to the commander of the Barracks, Gen. Constant Williams. The news quickly spread that, for the first time, a letter had been conveyed by air, and in only 40 minutes. The fickle northwest winds kept him from returning, however, and he had to land in a farmer's field. Even that was remarkable, and his two hours over Clark County set an endurance record. He would soon try heavier-than-air craft and never returned to dirigibles. He adopted a unique style of dress, a business suit with a diamond stick pin instead of the boots and riding apparel of other pilots, and he became one of the stars of the air exhibition world. His life came to an early end when, at age 28, he plunged into San Francisco Bay.

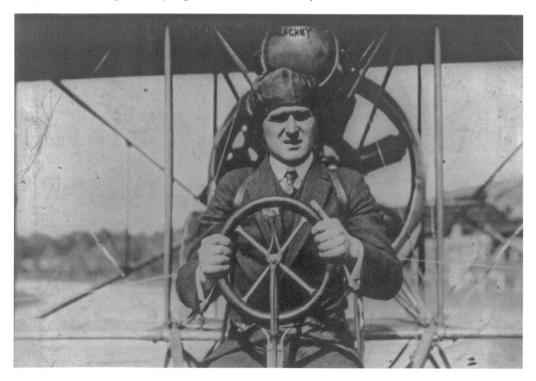

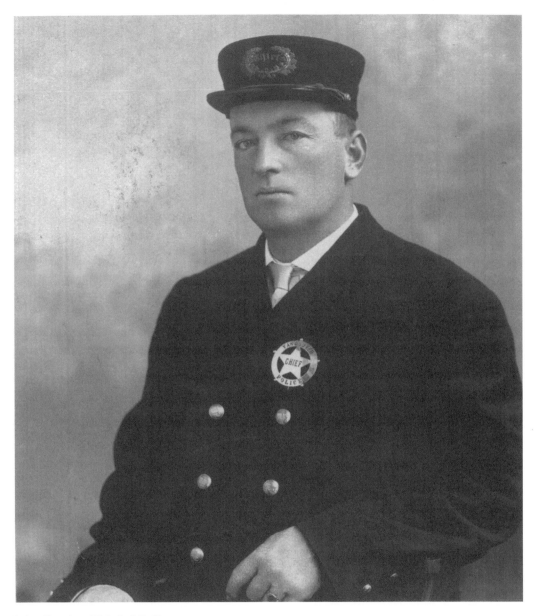

John Secrist, Chief of Police

Seth Secrist was sheriff of Clark County, and his son, John, served as his deputy during the 1890s. He left that position and became a patrolman for the City of Vancouver. The Alaskan gold rush was on, and he joined his brothers moving north. He came back, without gold, and was again hired by the police department. In 1902, the Elks Lodge was organized, and he became one of the charter members. In 1906, while chasing an Army deserter, Secrist fired a shot that ricocheted off the ground and hit the man in the back. He had not intended to hit the man and was relieved when the man fully recovered. He was appointed as chief of police by Mayor Edwin M. Green and served in that capacity until 1913. He then moved on to Tacoma, where he was appointed as a deputy US marshal. He kept that position for the next 20 years. Secrist never married and lived until 1954, when he died in Tacoma. (Vancouver Police Department.)

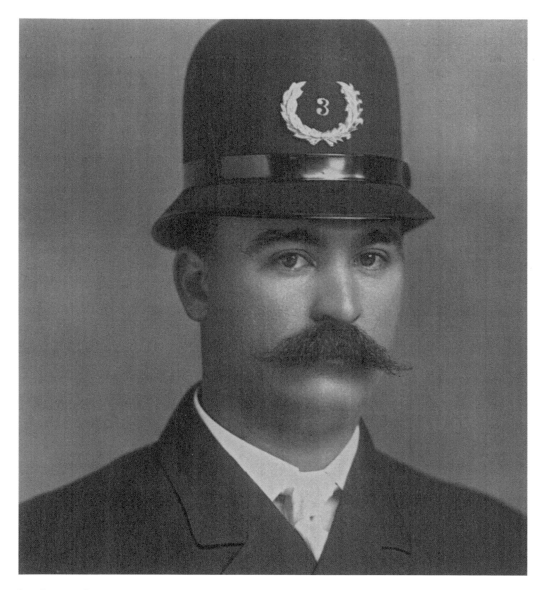

Ira Cresap, Lawman

Cresap was a policeman in the Vancouver Police Department in 1910 when he decided to run for sheriff. He won handily and served two terms, then was appointed chief of police by Mayor John P. Kiggins. The *Vancouver Columbian*'s editor remarked that "all criminals look alike to Cresap." One night, he was chasing a criminal who had robbed a streetcar. They ran through the railroad roundhouse on 39th Street. The robber whirled and fired a shot at Cresap. It bounced off his Elks pin and hit him in the neck. He whipped out his bandanna, wrapped it around his neck, and chased the robber down. He remembered his Army days when a soldier would be arrested for being drunk and would subsequently be given 30 to 60 days in the guardhouse. He thought that was unfair and double jeopardy. He asked General Marshall when a soldier was considered drunk under Army regulations. Marshall looked through the regulations, could find nothing specific, then told Cresap that if a soldier could stand up and order a drink, he was sober. Only if he passed out was he considered drunk. From then on, Ira would only charge soldiers with "sleeping on the street." (Vancouver Police Department.)

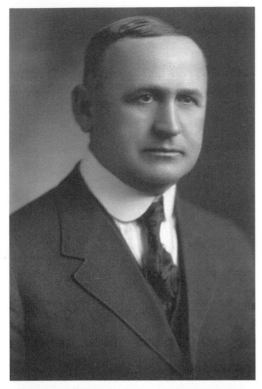

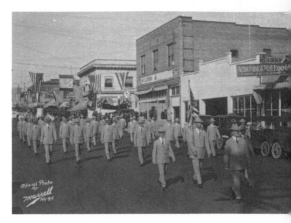

Perl M. Elwell, Interstate Bridge Commission

Downtown Vancouver began to boom in 1910, after the railroad bridge was opened. Among those who saw the need for a wagon bridge was Perl Elwell, who was in the real estate business with his brother John. He was part of the commission to build the Interstate Bridge and was a leader in raising money for the preliminary survey. He marched with the Prunarians (pictured on Main Street), a civic group whose motto was "We're full of prunes" and that inspired the Portland Rosarians. In addition to being a city councilman and police judge, he was an early member of the Vancouver Elks, which had formed in 1902. (Left, Vancouver Elks Lodge No. 823; above, Greater Vancouver Chamber of Commerce.)

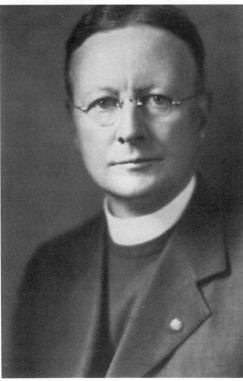

Otis Gray, Army Chaplain

Gray served at St. Luke's Episcopal Church beginning in 1909. The strong connection between the church and the military was apparent when, during World War I, Gray gave up his position at St. Luke's to become a chaplain in the Army. On a battlefield in France, he went to the aid of a fallen soldier, gave him Communion, and then carried him to safety. The two men would meet again in Wichita, Kansas, and together founded an Episcopal church there. (St. Luke's Episcopal Church.)

Otis "Bud" Smith, Athlete and Businessman
In his youth, Smith held the US lightweight wrestling championship. He held boxing titles as well and held boxing matches in the barn of his livery stable. He had inherited the stable from his father and took it over in the early 1890s. When the automobile came along, he changed with the times, operating the city's first taxicab business, which grew into Vancouver Cab. He was appointed acting city marshal while the regular marshal was away on business. Almost 30 years later, he was appointed constable and served for seven years until his death. (Hale Family collection.)

George Hubert Daniels, Tinsmith
The tinsmith trade was vital to an early city; tinsmiths were the equivalent of today's plumbers, welders, and metalworkers combined. George had come to Vancouver with his family from Ohio and learned his trade as an apprentice; he opened his own shop at 6th and Main Streets. Eventually he, in turn, would find another apprentice, Marshall Rowe Sparks, who would in turn buy the business and start his own. (Vancouver Elks Lodge No. 823.)

Marshall Rowe Sparks, Merchant

The last of the pioneer merchants, Marshall Rowe Sparks died in 1946. As a youngster, he had worked for his father learning the brickmason's trade. Then he apprenticed as a tinsmith and plumber to G.W. Daniels. At that time, the trades were almost synonymous. After 12 years, he bought the business and added a small stock of hardware. The business grew thanks to Sparks's reputation. In 1911 he built a bigger store at 605 Main Street and added sporting goods. Eventually it grew into a general merchandise store, and he moved yet farther north on Main. He was a member of the city council for several terms and was elected to the school board. He was a Shriner, and a master of his Masonic Lodge. He added the Oddfellows and the Knights of Pythias to his social calendar. His daughter, Norma, married Harry Craig and they began to manage the store. Marshall was still going to work every day after more than 60 years. (Sparks Family collection.)

Henry Jonathan Biddle, Environmentalist

Henry Jonathan Biddle was a mining engineer, a geologist, a naturalist and what we would call today an environmentalist. On the north bank of the Columbia River stands Beacon Rock, named by Lewis and Clark, who noted it was the end of the tidal influence on the Columbia River. In 1915, Beacon Rock was in danger of being destroyed by the Corps of Engineers, who wanted its tough rock for a jetty. To prevent this, Biddle bought it for a dollar from Charles Ladd, a Portland developer. He successfully worked to restore the name from Castle Rock to its original Beacon Rock. It had been climbed in 1901, and the pitons and scars from that climb were still visible. Biddle built a 4,500-foot-long, four-foot-wide trail to the top to forestall future damage. On his 300-acre estate on the north bank of the Columbia, Henry built his home. He had a fish hatchery on the farm, very near today's Columbia Springs Hatchery. Each day, the passenger trains would stop and buy fresh trout for the day's supper. Biddle Lake today is numbered among the city's parks. Working with the University of Washington, he collected and identified wildflowers and plants of the region, although he usually called himself an amateur botanist. He had studied in Germany, and it was there that he met his wife, Helene. They had two children, Rebecca and Spencer. (Above, Wood Family collection; below, author's collection.)

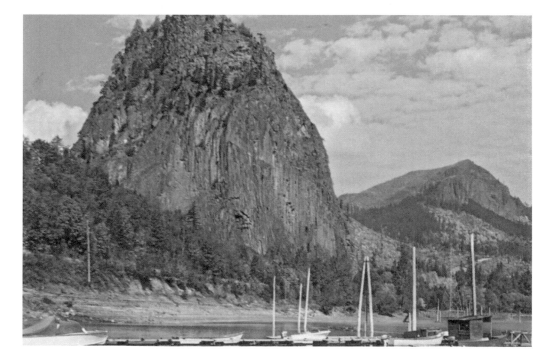

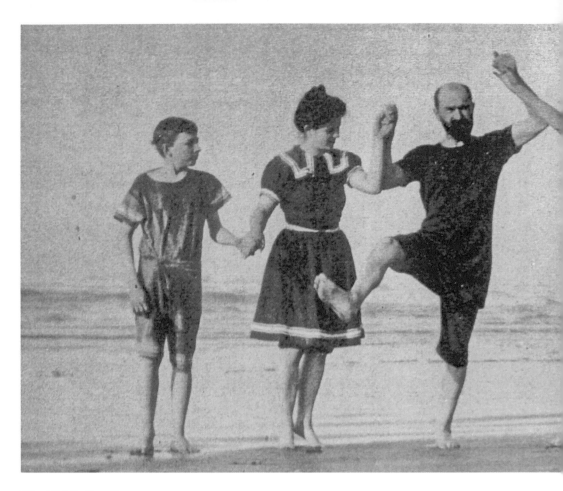

The Biddle Family
In a lighthearted mood that sums up the atmosphere of the early 20th century, Henry J. Biddle, who had built his mansion along the Columbia River, romps with his family: from left to right, Spencer, Henry Jonathon, obviously the head of the family, Rebecca, his daughter, and Helene, his wife. Rebecca and Spencer were to fulfill their father's wishes for Beacon Rock. Henry had made a park and picnic ground around the rock, as well as the trail that he had built to the top. In his will, Henry directed his children to sell the park to the State of Washington for the sum of one dollar, the price he had paid. The State refused the terms. Spencer and Rebecca then made the same offer to the State of Oregon, which accepted. The thought of an Oregon Park on Washington land aroused the ire of the populace. Washington quickly changed its mind. (Wood Family collection.)

Spruce Production Division (RIGHT)
During World War I, there was an urgent need for spruce wood with which to build airplanes. In the face of nationwide labor unrest, the solution was to form a combined military and civilian force. The Spruce Production Division was headquartered at Vancouver with the world's largest cut-up plant, serving nearly 50,000 workers. The plant and all of its buildings were erected in just 45 wet winter days in January and February 1918. On November 11, 1918, the war ended, and the plant shut down November 13. Pictured above, from left to right, H.S. Mitchell, builder, Maj. John Reardon, head of labor crews, Lt. Henry Dickerson, technical work, Lt. T.B. Lawrence, adjutant, Capt. O.P.M. Goss, assistant manager. (National Park Service Fort Vancouver.)

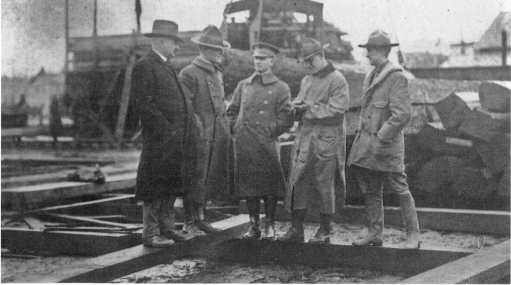

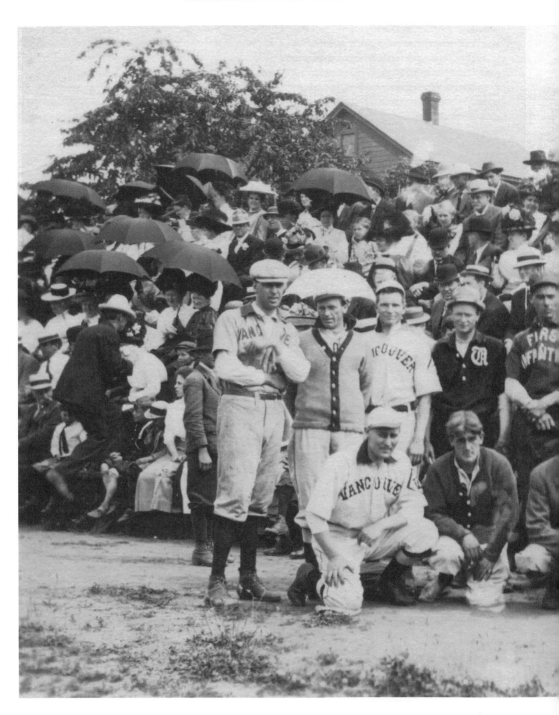

Vancouver Occidentals Professional Base Ball, 1911
Yes, that's base ball, two words. Vancouver had base ball as early as 1867, and had two teams, the Occidentals, a civilian team, and the Shermans, the US Army team. They played with and against each other and had matches across the river in Portland. It was a game for the up and coming white-collar men of the town, and the early-20th-century players have been compared to today's country club set.

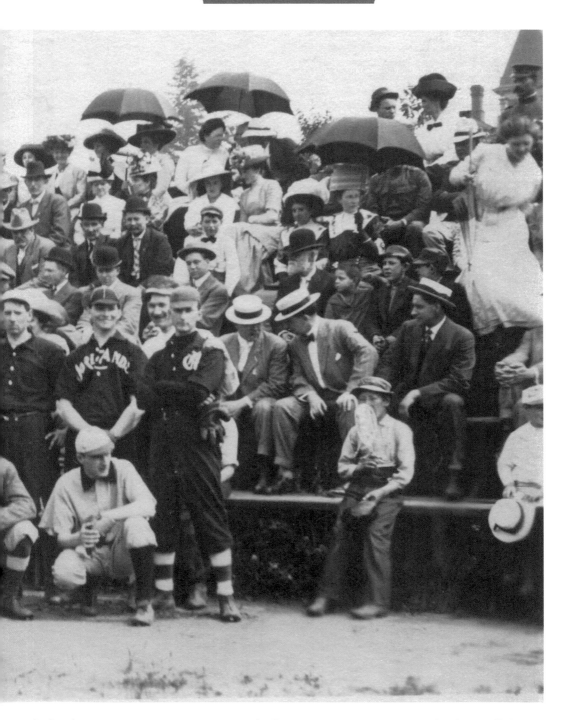

Ladies dressed for the occasion, bringing umbrellas to guard against the rain and/or the sun. Today the National Park Service at Fort Vancouver stages base ball games using the rules as they were written in 1860. Pictured from left to right are (front row) Clay Sparks, George Sutherland, Arnold Troen, and Charles Watts; (back row) C.C. Turley, E.M. Troen, Harry Burgy, Bill DuBois, John Marsh, Hugh Parcel, Gay Anderson, and Larry Doyle. (Vancouver Elks Lodge No. 823.)

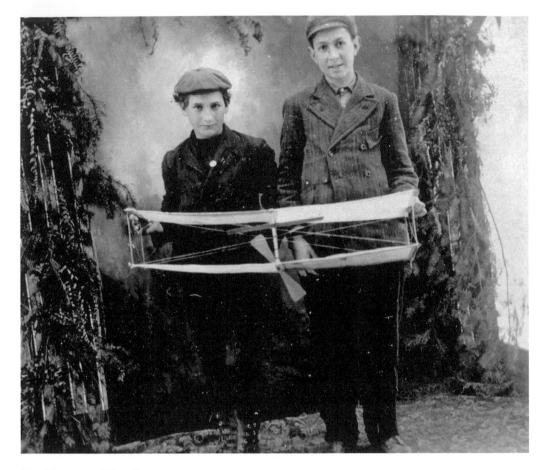

Fred Laws and Asa Ryan

In 1909 several young men from Harney School spent their lunch periods building airplanes from cedar, bamboo, and tissue paper. Two of the boys were Fred Laws and Asa Ryan. They were 14 and 15 years old at the time. Their model soared to 29 feet in altitude in just 10 seconds, not bad for a rubber band motor. Asa had long worshipped his cousin, T. Claude Ryan, owner of Ryan Aircraft. T. Claude was an innovative aircraft designer who built the *Spirit of Saint Louis* for Charles Lindbergh. Neither boy grew up to enter aviation; Asa went into the family business, Ryan Lumber, and Fred studied engineering and began his own construction company. (Ceci Ryan Smith collection.)

Albert Chumasero, Pharmacist (RIGHT)

Believed to be the first Filipino in Washington State, Alfred arrived in Vancouver in 1890. Orphaned when his father was killed in the Civil War, he was raised by an uncle near Oberlin, Kansas, and was given a well-rounded education. He graduated from Oberlin College. In Vancouver he met and married Mary Estelle Smith. With his brothers-in-law, he invested in several businesses. They built an electric generating station at the foot of Eighth Street. His primary interest, however, was City Pharmacy, later Chumasero Pharmacy, at 6th and Main Streets. There he compounded many of his own nostrums and elixirs. Those formulas were shipped all over the country. Today, bottles from his pharmacy are regarded as desirable collectibles. At the end, his medicines could not help him. He contracted tuberculosis and died in 1923. Below, Chumasero sits in his pharmacy at 6th and Main Streets. (Top and bottom, Hale Family collection.)

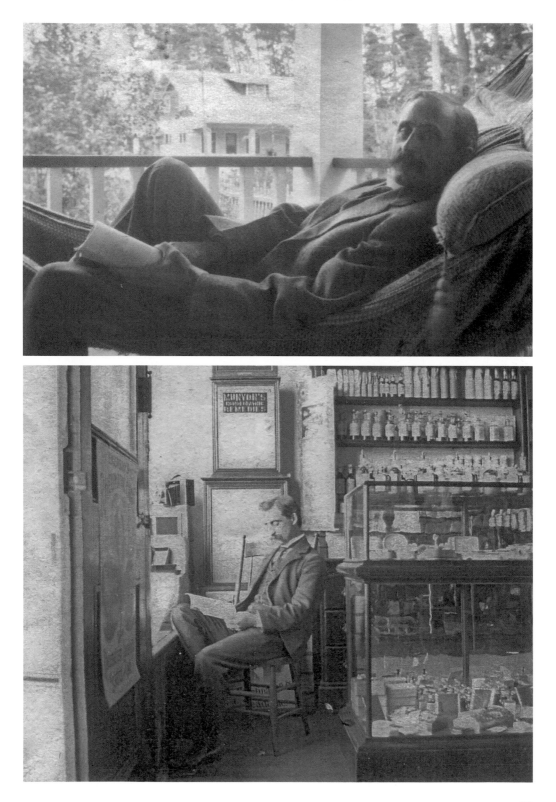

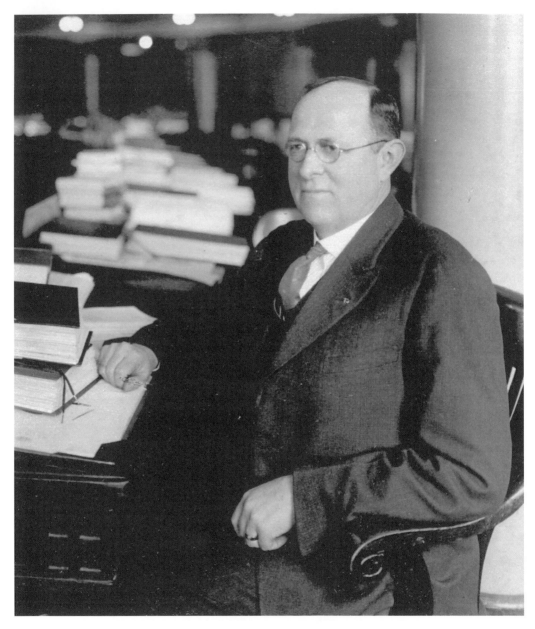

C.W. Ryan, Legislator

Claude Ryan was a part owner of the Ryan-Allen Lumber Company in Vancouver. The Allen and Ryan families had come west together from Kansas by train, but in style. They had a boxcar to carry their property, a palace car, and a sleeping car. He and Allen, the DuBois family, and other lumbermen formed companies, one of which became the Boise Cascade Paper Company. Ryan took time away from the lumber company to run for the State Legislature. He would serve seven terms in Olympia. One of the issues he dealt with most prominently was the Interstate Bridge, then a toll bridge. Clark County with Multnomah County in Oregon had bonded themselves to build the bridge, the cost of which was to be offset by a toll. He felt that was unfair, and his legislation enabled the State to buy the bridge from the county and remove the toll. (Ryan Family collection.)

Lloyd DuBois, Publisher

An ad in the *Vancouver Independent* brought Lloyd DuBois into the newspaper world. He became an accomplished printer and eventually set up a printing shop in the Vancouver Barracks. In 1894, he bought a share in the newspaper, and the following year he bought the remaining shares. President William McKinley appointed him as postmaster for Vancouver in 1899, and his brother ran the paper as he served his term. He was a crusader against vice in the city, particularly the "tenderloin," which had developed just outside the Barracks, in the area around West Reserve Street, and 3rd and 4th Streets. That entire neighborhood is now covered by the freeway interchange. When a bordello opened near his office, he declared himself for mayor on a reform ticket. He lost badly. DuBois sold his subscription list to the *Vancouver Columbian*, in 1910, but kept the presses. He opened as Pioneer Printing, and the business endured until computers and copiers made it obsolete. He established and was president of the Washington Exchange Bank, which later became Seattle First National Bank. His son died young. Heartbroken, Lloyd sold the bank that he had intended to be his legacy, but he stayed on as chairman of the board. (Vancouver Elks Lodge No. 823.)

Dr. Charles Irwin

The 100th person to join the Elks Lodge, Dr. Irwin was proud to carry a membership card numbered 100. He became mayor in 1915. Shortly thereafter, the city acquired what was called the "Tenney Site," which is now Park Hill Cemetery. There was a tremendous controversy over buying property so far out of town, because some citizens believed that poor widows would not be able to visit their husbands' graves. The dispute wound up in court, where the judge issued an order requiring Irwin to sign the contract. The United States entered World War I in 1917, and Irwin left office in 1918 and joined the Army as a dentist, a profession that he practiced in civilian life. (Vancouver Elks Lodge No. 823.)

John T. Urquhart, Artist

Following World War I, the big industries, the brewery, prunes, and the shipyards collapsed. In 1925 the city looked toward the centennial of the founding of Fort Vancouver and decided to plan a celebration to help change the city's fortunes. The US Mint offered to press half-dollar coins as commemoratives that could be sold for a dollar each, with the profit used to fund the event. Urquhart was a clothing store salesman, but an artist at heart. He drew a portrait of Dr. John McLoughlin, which the mint used for the coin. They minted 50,000 of them, but very few were sold. The remainder were melted down. Today, Urquhart's artwork is worth several hundred dollars and is very rare. On February 3, 1925, Lt. Oakley Kelly made a round-trip flight to San Francisco to collect the coins that had been minted there. Below, Herbert Campbell hands the first coin struck to Mayor N.E. Allen, who was to present it to Pres. Calvin Coolidge. The coin had been designed by Laura Gartin Fraser from Urquhart's drawing. Shown from left to right are Herbert Campbell, Oakley Kelly, Mayor N.E. Allen, Howard Warren, and an unidentified guard. Urquhart went on to work for the Washington State Department of Transportation. (Below left, Vancouver Elks Lodge No. 823; below right, *Vancouver Columbian*.)

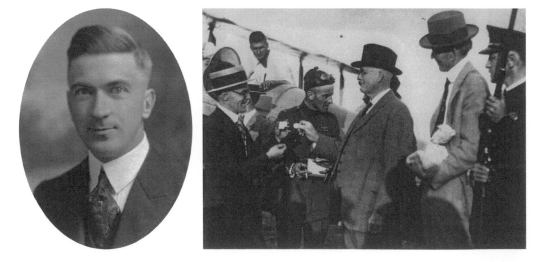

John P. Kiggins, Businessman and Politician
Kiggins came to Vancouver with the Army. He had served in the Spanish-American War in the Philippines and had boxed there. He was an amateur tap dancer and taught new steps to many young dancers. He started a construction business, which boomed with the opening of the Interstate Bridge. He ran for the city council, and then for mayor, serving nine terms in that position and two terms as county commissioner in the next 30 years. In 1929, on the Monday after the Wall Street Crash, John ordered the police department to move across the street. He then announced, and the council endorsed, that there would be a new city hall, "built like an office building in case it has to be sold in a hurry." The building opened in October 1930. He loved the movies and owned three theaters: the USA, the Liberty, and the American. He built two more theaters downtown, the Castle and the Kiggins (pictured). At Leverich Park, a stadium was built and dedicated as Kiggins Bowl. John immediately raised controversy by ordering dog racing in the remaining grounds of the park and at Bagley Downs as a means of raising revenue for the city. The county commissioners wanted dog racing too, although they knew it was illegal. Governor Martin ordered the State Patrol to arrest anyone gambling at Bagley Downs. The idea died. John was an energetic and forceful businessman and politician. He left his mark on the city. (Right, Denny Kiggins collection; below, author's collection.)

George Lamka, First Port Commissioner
The son of German immigrants, George came to Vancouver from Iowa with his wife Lena. He was in the real estate business and owned the Vancouver Implement company, selling farm equipment. An elected official as well, he was on the Vancouver City Council for seven years. On April 6, 1912, Vancouver voters overwhelmingly approved the formation of a port district (pictured). George was the first port commissioner. But the port had neither land nor money, and it would take a lot of work before it became a working operation. The port as it is known today is an international operation, shipping grain and lumber out, and accepting automobiles and wind power equipment. (Right, Port of Vancouver; below, author's collection.)

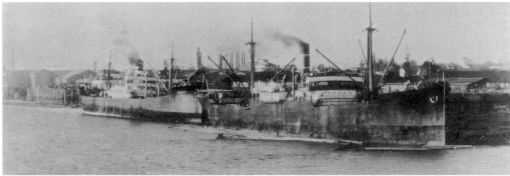

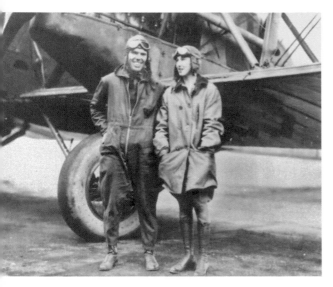

Alexander Pearson, Aviator
In the early days of aviation, both civilian and military pilots flew out of the airfield at Vancouver Barracks. After World War I, the army realized the importance of aviation and established a base there. The 321st Observation Squadron arrived in 1923. In 1925, the Army asked that the airfield be named in honor of Alexander Pearson, a daredevil pilot who had died in a 1924 crash preparing for the Pulitzer Air Race in Ohio. Pearson was from Kansas and graduated from the University of Oregon. For years Vancouverites believed that Pearson had gone to school in Vancouver. The pilots at the field concocted the story to help convince the city to accept the name, but it was proved to be untrue. (National Park Service.)

Dr. Herbert Lieser
Grandsons of the original Land Claimant, Louis Lieser, the three brothers Ralph, Miles, and Herbert Lieser became physicians and practiced together. When World War I began, they closed the downtown practice and joined the Army Medical Corps. The Spanish flu pandemic struck Vancouver in October 1918 and claimed Miles as a victim. The two surviving brothers reopened their practice after the war, but Ralph had a heart attack at 39 and died. Herbert continued on alone. He had joined the Elks Lodge and served as their exalted ruler. He was appointed to the State Board of Health and was on the board of the Columbia River Paper Mill well into his 80s. (Vancouver Elks Lodge No. 823.)

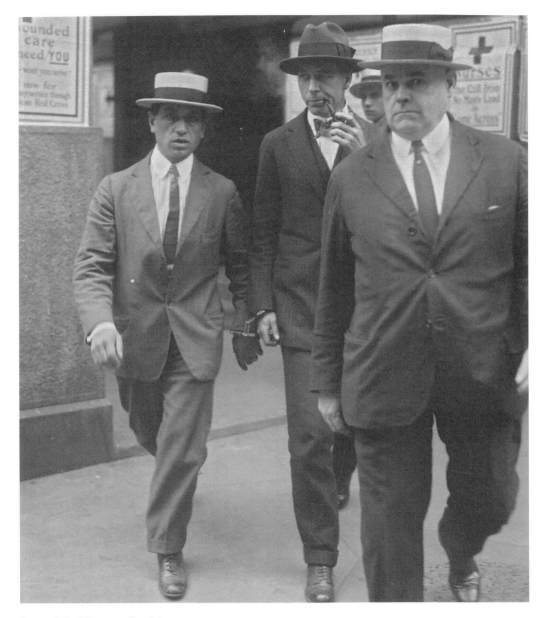

Jeremiah O'Leary, Fugitive

Pictured here with two unidentified Department of Justice agents, Jeremiah O'Leary, center, was Vancouver's egg man during World War I. Vancouver, however, knew him as James Waters. He was on the run from the Department of Justice on charges of treason and sedition. He had been a successful lawyer in New York, and a member of Sinn Fein. He published a virulently anti-British magazine called *Bull*. Congress had passed the Treason and Sedition Act, which suspended the rights of free speech, free press, and the right of assembly. O'Leary published an article arguing that the best thing for the United States would be for Britain to lose the war. That was enough. A warrant was issued, and Jeremiah ran. Eventually the Department of Justice agents caught up with him, and he returned to New York for trial. He was found not guilty on all counts, and when the war was over the Act was declared unconstitutional. (Library of Congress.)

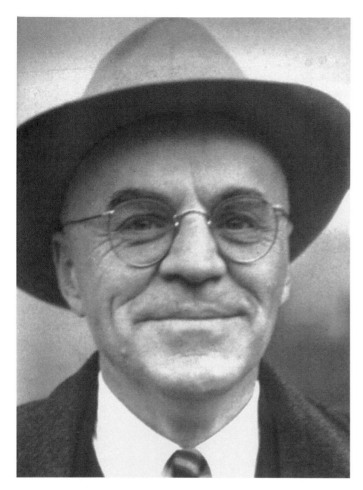

Herbert Campbell, Newspaperman

Campbell graduated from the University of Oregon in 1904 and went to work as a cub reporter at the *Spokane Chronicle*. He worked at the sports desk, then briefly at the *Oregon Journal*. For the next few years, he worked for newspapers across the Pacific Northwest. In 1921, he took over the *Vancouver Evening Columbian*. (The *Columbian*'s offset press is pictured.) The newspaper office was then at Second and Main Streets. He moved the office to a new building at Evergreen and Broadway, where it stayed until 1955. Then he grew again to a facility on Eighth Street. In 1926, for the City's centennial celebration, the US Mint in San Francisco produced half-dollars with Dr. John McLoughlin on the face. Famed aviator Oakley Kelly was to fly $50,000 worth to Vancouver to sell as a fundraiser for the celebration. Campbell was on hand to greet Kelly at Pearson Field and accepted one of the first coins. The *Columbian* took an active part in that celebration, as it did others. When an Elks Convention was held in the city, Campbell printed the entire paper in the Elk color, purple. He crusaded to shut down illegal dog racing and other gambling. In 1941, Herbert Campbell died of a heart attack while driving home. (Top and bottom, *Vancouver Columbian*.)

Lester Wood, Sheriff

In 1926, Democrat Lester Wood had little chance of winning his bid for sheriff. But the first Republican nominee dropped out when it was disclosed that he had lost his citizenship for deserting the Army. The second had ties to the Ku Klux Klan and had failed to pay his taxes. Lester won easily. He was sworn in in January 1927. His first priority was to fight a "ruthless war on liquor violators." He lost that war on May 22, 1927. He and three deputies closed in on Luther Baker's still in Dole Valley. A gun battle erupted, and Lester fell with a bullet just above his hip bone. He was dead in minutes. Luther, his brother Ellis Baker, and Luther's nephew Ted Baker were soon captured and convicted of the crime. Luther was hanged, and Ellis served a life sentence, but Ted's conviction would be overturned. Lester Wood is the only elected sheriff of Clark County who has ever lost his life in the line of duty. (*Vancouver Columbian.*)

Rev. Charles Baskerville
Charles Baskerville, a community-minded man, was the pastor of the First Presbyterian Church for nine years until his tragic death in the Columbia River (pictured). On a hot autumn Sunday afternoon he, his wife, and daughter, accompanied by their friend, Dr. Dwight Parish, set out on a picnic just east of the city near Blurock's Landing. Mrs. Baskerville and their daughter Barbara slipped into a sinkhole while wading on a sandbar. Hearing her cries, Baskerville leapt into the water to rescue her. So did Dr. Parish. Parish grasped Mrs. Baskerville and pulled her to safety, then clutched Barbara's hand. But Baskerville was nowhere to be seen. Hours later his drowned body was dragged up. (First Presbyterian Church.)

Dr. Dwight Parish
Dwight Parish had a genius for spectacles. In addition to his work as an optometrist, he staged unique and ingenious celebrations for the community. He was the mind behind the Prune Festival and the Apple Tree Festival, and he staged an elaborate circus pageant for his Rotary Club. He was so recognized for this talent that the *Columbian* remarked that he was "one of those leaders who make for a community's individuality." But his most memorable adventure was when he accompanied the Baskerville family on their picnic. He rescued Mrs. Baskerville and her daughter, but was unable to save Mr. Baskerville. (First Presbyterian Church.)

Mary Conboie Schofield, First Female Bank Director in Washington State
Originally from San Francisco, Mary Conboie married Edward R. Schofield, a very successful Vancouver businessman, in 1906. Her maternal grandparents had settled in Vancouver in the 1850s. Family legend said that the first Catholic priest in Vancouver had given her grandmother an elaborate candelabrum, which she treasured. Edward died in 1920, and Mary carried on his many businesses. Their holdings included properties in both downtown and uptown Vancouver. Mary became the director of the bank and is regarded as the first woman bank director in the state. The terms of Mary's will affected the city. Her children inherited all of the properties, but could not sell them nor borrow against them. As the buildings aged, it was impractical to invest in them, nor borrow against them to update or repair. That ban was lifted for the grandchildren, who would be able to manage the properties as they pleased. (Schofield Family collection.)

William Charles Bates, Attorney (RIGHT)
Billy Bates met his future law partner, L.M. Burnett, on his first day at Vancouver High School in 1902. They attended the University of Washington together and the partnership continued through 50 more years until retirement. He ran for the Legislature on the Bull Moose Party ticket supporting Teddy Roosevelt, but the voters rejected the third party. Then he ran again, this time for Vancouver city attorney. He was elected for six consecutive terms, 1917 to 1929, and then another term from 1942 to 1946, during the eventful World War II years. In his entire career as an attorney, he had but one criminal case, involving a man accused of stealing a red warning lantern. Bates successfully defended the man. After he was exonerated, and they began to discuss payment, the man asked Bates if he would accept a red lantern as payment. Bates never took another criminal case. (Vancouver Elks Lodge No. 823.)

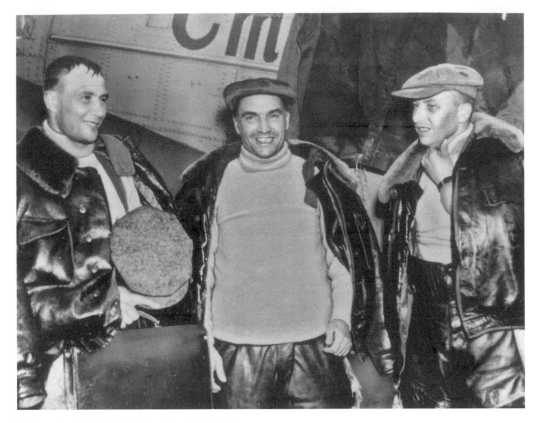

Valery Pavlovich Chkalov, Soviet Pilot

On June 20, 1936, a huge red plane glided over the Interstate Bridge and landed at Pearson Field. It was the Soviet ANT25, which had taken off from Moscow 65 hours before and, for the first time, successfully transited the North Pole and joined two continents. Pictured from left to right are Georgi Baidukov, Valery Pavlovich Chkalov, and Alexandr Belyakov. They were soon greeted by Gen. George Marshall, who had thrown his uniform and boots over his pajamas. The Soviets were well aware of the experiences of Charles Lindbergh when he had landed at a civilian field in Paris. They would not

risk their plane. When it was apparent that they would not have enough fuel to reach San Francisco, they chose Pearson Field, a military installation. A two-month whirlwind tour of the United States followed, culminating in a visit with President Franklin Roosevelt. Chkalov was killed in a test flight in December 1938. Baidukov and Belyakov returned to Vancouver to dedicate a monument to commemorate the flight, which still stands at Pearson Field. The bronze castings were done in the USSR, and the stonework was done in Vancouver. It was originally on Highway 14 south of the field, and then moved to the field itself. (Above, National Park Service; left, author's collection.)

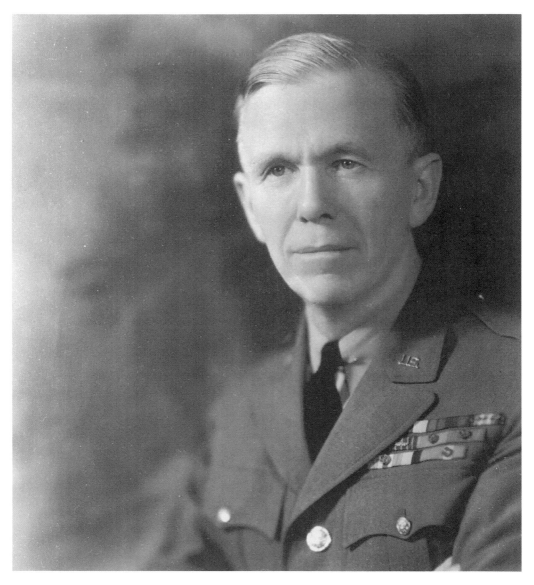

Gen. George C. Marshall, Architect of Victory
The author of the Marshall Plan that rebuilt and fed Europe after World War II, General Marshall headed up the Civilian Conservation Corps from the Marshall House on Officer's Row. When the Soviet transpolar flight landed in June 1936, Marshall jumped into a Jeep and rushed to greet them. He offered them a bath and breakfast. In October of that year he was promoted to brigadier general. Soon he was called back to Washington to become Army chief of staff. He was credited by Winston Churchill as the "architect of victory." After the war, he became secretary of defense, and then secretary of state under Pres. Harry Truman. For conceiving the plan that would bear his name, he received the Nobel Peace Prize, the only career soldier ever to be so honored. He then became the head of the American Red Cross. Vancouver is one of the "Marshall Cities," recognized by the Marshall Foundation for Leadership, and each year hosts the Marshall Lecture on Leadership. A Marshall Award and a Junior Marshall Award are given to young citizens of Vancouver who have demonstrated the qualities that Marshall possessed. (Library of Congress.)

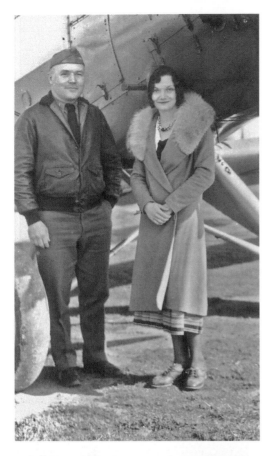

Carlton Bond, Aviator

The only twice-appointed commander of Pearson Field, Bond joined the Army in 1916, and served in the Mexican Border campaign. In World War I he graduated from one of the Army's first classes in aviation as a balloonist for the Signal Corps. He then became a pursuit plane aviator. He commanded Pearson for the first time from 1929 until 1933. During his tenure, the landmark first flight from Moscow to New York touched down after an engine malfunction. An ANT4, named "The Land of the Soviets," it was repaired and continued its diplomatic mission. Bond was reassigned to Pearson Field in 1938 and remained until 1940. Bond had a reputation both as a man's man and a ladies' man and fulfilled both roles with enthusiasm. He is pictured with a friend, Sunny Day. (National Park Service.)

Horace Daniels, Banker

The second person in Vancouver history to be named as Citizen of the Year, Horace was a banker. He began as a young man as a teller, then worked his way up until he was the president of the Clark County National Bank when it merged with Seattle First National Bank in 1947. Horace cast a wide net of involvement. He was the first director of the Lions Club when it organized in 1928. He was master of Washington's No. 4 Masonic Lodge, and he was on the planning commission for many years. It was said that whenever there was a community event, Horace would be in the forefront working. Daniels Street in Vancouver is named for him. (Left, Vancouver Masonic Center; below, author's collection.)

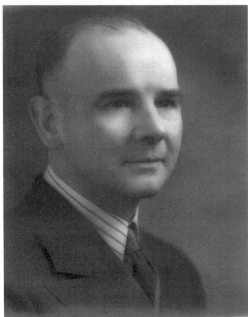

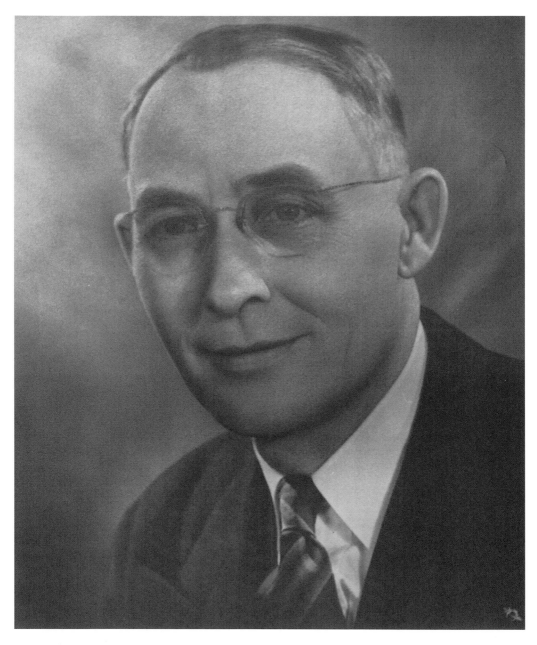

Joe Breckel, Reluctant Mayor

In 1936, Vancouver had three mayors. Late in 1935, Mayor Ed Hamilton was in a traffic accident. He died in January 1936. C. Art Pender was selected by his fellow city councilmen to be mayor until the next election. To fill his seat, Joe Breckel, a popular young ice-cream company executive, was chosen. A few months later, Pender decided that it was a terrible job, and he resigned. None of the other councilmen were interested in being mayor, so rookie Breckel was promoted. He did a good job, to judge by the newspapers, but he hated it more each day. In October, he announced that he would not run for election. Perennial mayor John Kiggins, who did love the job, was elected for another term in 1937. (Vancouver Elks Lodge No. 823.)

Lloyd Ryan, Businessman
When Ryan decided that he wanted to rise up the corporate ladder at Bell and Howell, he didn't send the usual letter of application: he sent a movie. He and his wife made a film showing his progress. It included a shot of a typewriter, with him typing out the application, then showed his college days, him selling, shots of his feet walking on a sidewalk, more selling, and ended with him and his wife boarding the train to Chicago, having gotten the job. It worked, and he was hired. When World War II came, he joined the Air Force and retired as a colonel in 1956. On the way he picked up a doctorate; he was a consultant for General Electric and, at the time of his death, a director at the Illinois Institute of Technology. (Ryan Family collection.)

CHAPTER THREE

Boom and Echoes

In February 1942, Vancouver was a small Army town, still reeling from the attack on Pearl Harbor two months before. That month Henry Kaiser announced he was going to build a shipyard in Vancouver at Ryans Point. By July, the first ship was sliding down the ways of the barely finished yard. Thousands of people descended on the town from across the nation. Under an order from President Roosevelt, the Vancouver Housing Authority was formed to build six wartime towns. Vancouver heard strange accents and saw faces of different colors. As the trainloads of workers poured in, they moved into houses still smelling of sawdust. The Authority placed the people in the next housing available, so there would be enclaves of people from the same place. When the war ended, it was obvious that McLoughlin Heights had the potential to be the country's biggest slum. It had to be removed. New neighborhoods were laid out and new homes were built. The Housing Authority, working with the city, found homes across the county for the displaced. African American residents were placed just like everyone else, with the NAACP, the churches, and the city working together to make that happen. The result is that today there are no ethnic neighborhoods in Clark County. There are neighborhoods determined by economic levels, but no ghettos, barrios, or Chinatowns.

After the war, the shipyard closed, the population dropped by half, and businesses closed. The freeway cut through the city in the 1950s, bypassing downtown. Jobs in Oregon were easier to reach. A shopping mall at the south end of the bridge lured customers from downtown. The tax differences between the two states created a tax haven of sorts: there is no income tax in Washington, and no sales tax in Oregon. Vancouver began to assume the status of bedroom community. There were people who treasured the city, there were the descendants of pioneers, and there were the newcomers. As many attached to the Barracks through the years had stayed, so did many from the World War II era.

Elwood Caples, Visionary

Caples, over many decades, touched every part of life in Vancouver. He organized the Public Utilities District. He was first elected city attorney in 1928 and served for 12 years, leading the city to acquire the private water company and to build Kiggins Bowl as a WPA project. He is best known as the driving force of the Vancouver Housing Authority during the boom years of World War II. The construction of the six wartime cities was accomplished during his watch. Perhaps more than anyone else, Caples saw that the remnants of the wartime housing would become a horrendous slum. He convinced the Housing Authority to buy the Heights, dismantle the projects, and redevelop the areas. The transformation was accomplished and the mortgage was paid off in 18 months. More important was his determination that there be no segregation in housing in the new areas, or anywhere else. Working with churches, the NAACP, and volunteers, that goal was accomplished. The city today has no ghettos. (*Vancouver Columbian.*)

Frank Blaker, County Treasurer
Not many have served as county treasurer for as long as 33 years. Blaker was elected again and again. He was a winner of the Good Government Award, and life member of the Vancouver Elks. Frank Blaker never bragged about his accomplishments. But as a fisherman, he was eloquent about his past triumphs and had glowing predictions about fishing trips to come. To distract him, his employees would casually ask about his last expedition, knowing that he would launch into that story and forget what he had come into their office for. He was so highly regarded that on the day of his funeral, the Clark County Courthouse closed from 1:00 to 3:00 p.m. (Vancouver Elks Lodge No. 823.)

Pierre DuPaul, Fire Chief
DuPaul was the son of a French Canadian father and an Irish mother. They had immigrated to Connecticut, where Pierre was born. He grew up there and joined the Army. That brought him to Vancouver, where he joined the Vancouver Fire Department. He was the longest-serving fire chief in city history, from 1937 until 1957. He faced the immense problem of maintaining public safety as his young firemen were drafted into the military. He wrote a letter to the mayor stating, "If they start drafting men with children, I'll have to shut down the department." He faced tragedy at home too. His wife, Helen, died of carbon monoxide poisoning in May of 1944. She was only 39 years old. (Vancouver Fire Department.)

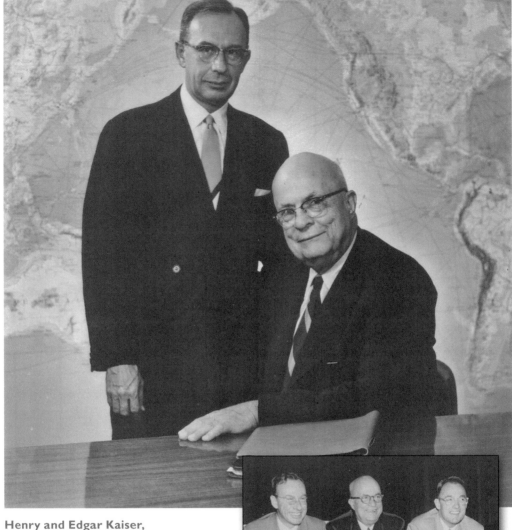

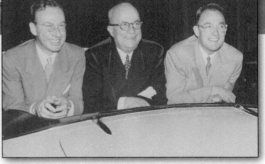

Henry and Edgar Kaiser, Shipyard Builders

Henry Kaiser spotted Vancouver as he was traveling on the Columbia River helping to build the Bonneville dam. In February 1942, he announced he would build a shipyard at Ryans Point. By July, the shipyard was open and already building ships. He offered his employees a job, medical care, housing, and child care for working mothers. Vancouver's population swelled from 18,000 to over 80,000. Edgar Kaiser lived in Vancouver and personally oversaw the shipyard and the construction of the first Kaiser Permanente hospital in the Northwest. At the end of the war, the Kaisers proposed building airplanes at the yards. Boeing Corporation was already building airplanes in Washington and raised objections. The first Kaiser automobile was built at the shipyards in Vancouver, but that operation moved to Michigan, and the shipyards closed. The lower picture shows, from left to right, Edgar, Henry, and Henry Jr. in a Fraser Manhattan Convertible. (Kaiser Family Foundation.)

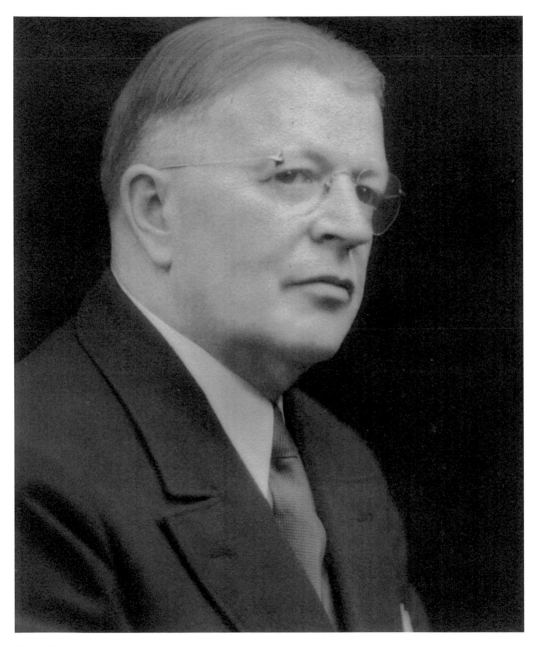

Fred Sinclair, Port Commissioner
During World War II, Fred Sinclair was elected as a commissioner for the Port of Vancouver. Upriver from the fort, the Kaiser Shipyard was already anticipating the end of the war. There was a labor force of thousands. Sinclair resigned from his post, ran for mayor of Vancouver, and was elected. The City had a commission form of government then, two commissioners and a mayor. At war's end, at a time when many important decisions had to be made, Mayor Sinclair suffered a stroke. Through the long months, many votes would end in a tie, and a call would go out to the mayor's doctor: "Could he vote?" "No," would come the reply. Issue after issue would fail, and opportunities slipped away. The stalemate caused by Sinclair's illness would impact the city for a long time. (Vancouver Masonic Center.)

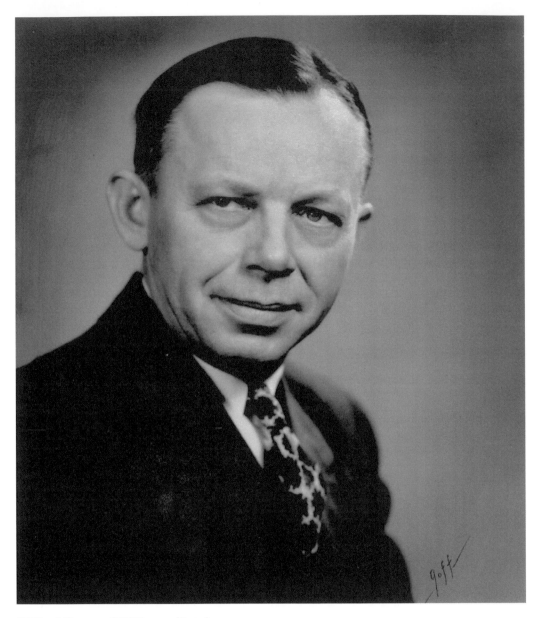

Clifford Koppe, Cliff Koppe Metals

Koppe was an intellectual man who achieved success in spite of hard times. Born in 1902, he was too young for World War I, and too old for World War II. He graduated from the University of Washington in 1926, intending to go on to law school. However, work and the Great Depression intervened, and he had to take a job at a service station. Through that job, he met men who dealt in auto salvage. During the 1930s, most of the auto salvage men were Jewish and spoke Yiddish. Koppe was fluent in German and was able to talk with them. They taught him the business and helped him get started in the business. He started his auto wrecking company in Washougal during World War II, a necessary business then when no new automobiles were being manufactured. After the war, in 1946, he bought the property on Fourth Plain that was to become Cliff Koppe Metals. Koppe died young, 57 years old, in 1959. His family has carried on the name and the business. (Vancouver Masonic Center.)

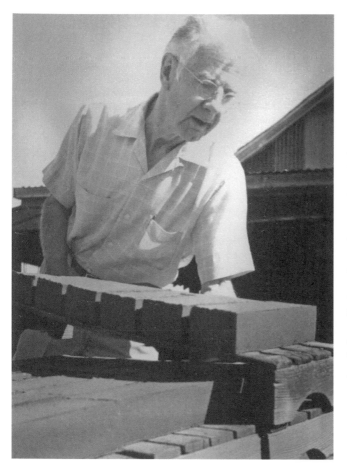

Robert Arthur Hidden, Hidden Bricks

Hidden, known as "Bob," joined his father's brick company in 1929. In that year, the first bricks were produced with the well-known Hidden imprint. The bricks were among the last in the nation made in the sandmold process, by hand. A Hidden brick today is a valued addition to a walkway or flower bed. Bob served on the city council and was a longtime board member for Memorial Hospital. His respect for the history of his city flowered when a developer bought the venerable Providence Academy with the intention of razing it and building the Academy Condominiums. Bob bought the academy, and it stands today, an icon of the city. The classrooms are used as office space, and the chapel designed by Mother Joseph is in demand for weddings. (Hidden Family collection.)

Ella Wintler, Teacher and State Representative

Wintler grew up with four brothers, three half-brothers, and one half-sister. She attributed her stoic strength to that childhood. When paid a tribute, she said, "Had I not been raised with seven brothers, I would cry. But I was, so I won't." She was one of 12 graduates from Vancouver High School in 1903 and taught for a short time before going to the University of Washington. She returned to Vancouver after a short stint in Mt. Vernon and taught at Vancouver High School until she retired in 1950. A Republican, she ran for state representative in 1938, won, and served 10 two-year terms. She would lose if the Democratic Party came to power and win when the Republicans did. Wintler was a member of the Association of Retarded Citizens, now called the Arc, and vigorously worked for bills for developmentally disabled children. The State School for the Blind in Vancouver received her close attention, as did all area schools. (Information Office, State of Washington.)

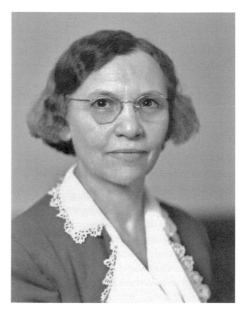

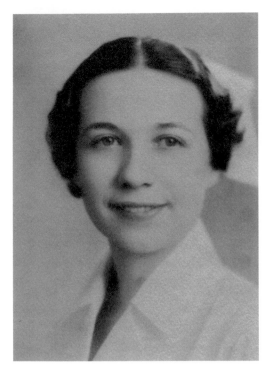

Elizabeth Ryan, Nurse

Elizabeth Kinkella Ryan received her nurse's cap from St. Mary's in Portland. Dr. Clyde Ryan, Vancouver's favorite dentist, met her and fell hard. He wanted to marry right away, but Elizabeth was not so sure. She travelled up to Alaska Territory to serve as what would today be called a nurse practitioner. On a trip back to Vancouver with a patient, she saw Dr. Ryan again. He thought he had waited long enough. This time Elizabeth agreed, and they were wed. They bought a house near Hough School, and Dr. Ryan left with the Army Medical Corps. She was determined to pay off the house before he came home, so she rented rooms to young people brought to the city by the war. Romances would flourish, and they would ask her for a place to have the ceremony. She offered her living room, a veil, flowers, candles, and a cake. The family still has photographs of many bridal couples standing in front of the fireplace in that room. (Smith Family collection.)

Dr. Clyde Ryan

Ryan was the son of lumberman and legislator C.W. Ryan. He graduated from the dental college at the University of Oregon, then joined the 46th General Hospital US Army, headquartered in Portland, Oregon. During World War II, while the members of the unit were overseas, they would talk about their homes in Oregon and Washington, and what was needed. The biggest idea was a science museum. OMSI, the Oregon Museum of Science and Industry in Portland, had its seed in those conversations. Dr. Ryan came home to Vancouver and his wife Elizabeth after the war. He found that his former office had been rented to someone else. He opened his practice in an office built onto his home in the Hough neighborhood. There he practiced for the rest of his life. (Smith Family collection.)

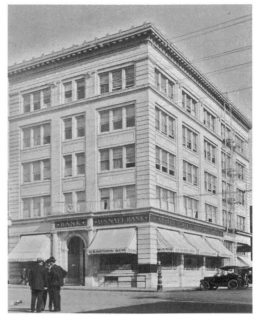

J. Guthrie Langsdorf, Lawyer and Superior Court Judge

Langsdorf was the son of successful bankers. His family had owned United States Bank (pictured), the building now known as the Heritage Building, at 6th and Main Streets. He, however, went into the practice of law. He followed that calling until World War II, when he joined the Army Air Corps. He served in China, Burma, and India, emerging at the end unscathed, with the rank of lieutenant colonel. He returned to Vancouver to his wife Dorothy, and to his law practice. In 1955 the State added a second Superior Court judge's seat, and Langsdorf was installed in that position. He would serve for 22 years as a Superior Court judge, occasionally acting as State Supreme Court Justice Pro Tem. (Above left, Vancouver Masonic Center; above right, Greater Vancouver Chamber of Commerce.)

Dorothy Langsdorf, Trailblazer

Teachers could not be married in Dorothy's day, so she had to quit when she married J. Guthrie Langsdorf. It would be the last quitting she ever did. She was the first president of the Fort Vancouver Regional Library Board, she persuaded the telephone companies to list the wife's name as well as the husband's in their directories, and she convinced the county auditor to print thorough explanations of issues in the voter's pamphlets. But the effort for which she is most remembered sprang from a short article in *Reader's Digest* in 1968. It offered a $500 grant for "worthwhile projects." She won the grant, and with the money bought shovels and tools to start clearing Discovery Trail. Today on the trail there is a bench, and on the concrete pad around it is inscribed in her handwriting, "A trail is a place to enjoy a walk, and find a bench to rest and talk." (Langsdorf Family collection.)

Rudy Luepke, Florist

Luepke came to Vancouver from Texarkana, Texas, with his parents when he was just an infant. His father started a florist business at 13th and Washington Streets in 1909, and Rudy would eventually take over the business. He opened the iconic building at 13th and Washington that housed his business in 1938. It is still standing, and the business still bears his name. He joined every civic booster club in Vancouver, and he was a president of most—the chamber of commerce, Kiwanis, Elks, Royal Oaks Country Club, Gyros, Jaycees, Stockaders—and he chaired the Regional Planning commission. You would expect someone that involved to enter politics, and you would be right. He was elected to the Vancouver City Council in 1953. In those days the mayor was elected by the council, and Luepke gained that position in 1962. He stayed as mayor until he lost his bid for reelection in 1967. The Luepke Senior Center was named in his honor. (Right and below, Luepke Florist.)

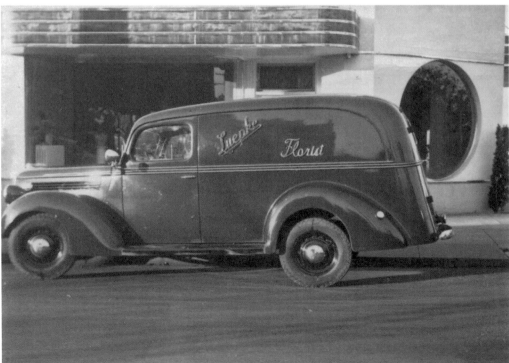

Val Joshua, Teacher

Valree Jacqueline Joshua was born in Texas and grew up on a farm. Texas was a segregated place then, so she attended an all-black school. The classes were crowded, and the teachers didn't have much time for the individual child. But her parents helped each of the children to learn. She went on to Wiley College in Marshall, Texas. There she met her future husband, Joseph. Her first teaching experiences were teaching children not much younger than her. Val and Joseph came to Vancouver during the World War II years. She wanted to teach and heard of a position with the State School for the Deaf. Because she had no experience with deaf children, she went to Lewis and Clark College in Portland to learn sign language and the ideology of the deaf. Later she would take her master's degree in education there. Val joined the NAACP as soon as it was formed in Vancouver and later remarked that there were more white members than black. She was one of the leaders who made and kept Vancouver as an integrated community. Music was also a major part of Valree's life. She began in Texas in choirs, and when a chorale was formed in Vancouver, her talents were immediately tapped. She sings with the Bravo Vancouver choral group, She will still sign with anyone she sees signing; it is necessary, she points out, to keep practicing. Her favorite saying is and has been, "You get an education. That is something no one can take away from you." Each year the YWCA in Clark County bestows the Val Joshua Racial Justice Award, named for a determinedly color-blind woman. (Valree Joshua collection.)

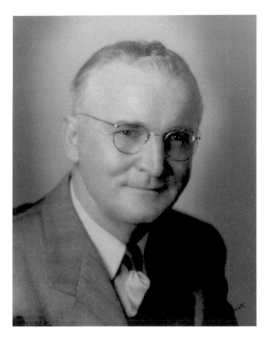

Al Stanley, Mayor

Stanley had a family business, Comstock and Stanley, a grocery store on West 26th Street (Fourth Plain today). When the business failed, he became a fireman. At the end of the Great Depression, Stanley was elected mayor of Vancouver. He saw the oncoming boom as the Kaiser Corporation announced their intentions to build a shipyard. The end of the war found him an elected county commissioner. A bitter quarrel erupted among the commissioners over the firing of the county roads supervisor. Stanley threw up his hands and resigned as president of the Board of County Commissioners, although not his seat on that board, and went off to Hawaii on his honeymoon. The two commissioners left behind found it difficult to agree on anything. Unfortunately, that occurred at the same time that the City of Vancouver was facing a similar impasse upon the death of Mayor Fred Sinclair. (Vancouver Masonic Center.)

Brazola Reddick, Social Worker

For her untiring efforts to promote racial equality, Brazola Morris Reddick was named Woman of the Year by the Vancouver Business and Professional Women's Club in 1964. She was a social worker for over 30 years, in Vancouver and in Seattle. She helped to write a report for King County on rehabilitation of welfare recipients. Brazola was a charter member of the Vancouver branch of the NAACP and was an integral part of the city's effort to develop a housing policy. (Bertha Baugh collection.)

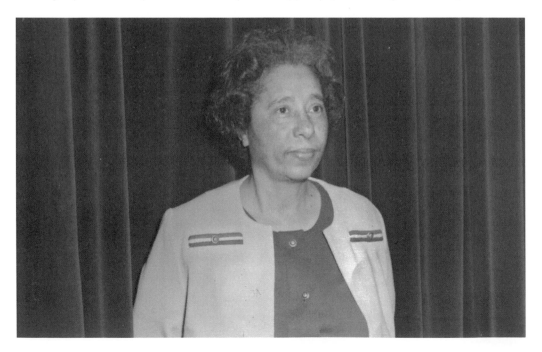

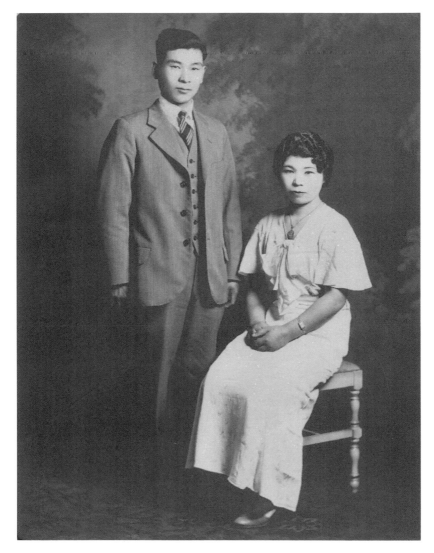

Lillie and Kaino Ono, Wedding Day

A small rocky farm in Orchards, Washington, was Kaino and Lillie Ono's first farm. They grew lettuce and did fairly well. They had two children and one on the way. Kaino's brother, Mojiro, farmed in the Burnt Bridge Creek bottoms. They were struggling to buy their property when December 7, 1941, killed all their dreams. Fear and perhaps a sense of vengeance led to a mass removal of all Japanese on the West Coast, American citizens or not. Mojiro fled home to Japan. Kaino and Lillie chose to stay along with their children. But soon, the government came for the Onos. Their possessions were auctioned off, and they were loaded onto a train for Tule Lake. They arrived with nothing more than what they and the children could carry. The family was assigned to a 300-square-foot room that shared a mess hall, toilets, and bathing facilities with other families. Kaino passed some of his time carving wooden animals: Bambi, Thumper, Flower, the creatures of the Disney films. When the war ended, the Ono family came back to Vancouver. The farm had been left to go to seed. Although they had bought it once, they had to buy it again. With borrowed and second-hand equipment, they started over. The Ono family is still on the land, now called the Lettuce Fields. They don't talk about those days much. Lilly says: "Those were terrible days." (Ono Family collection.)

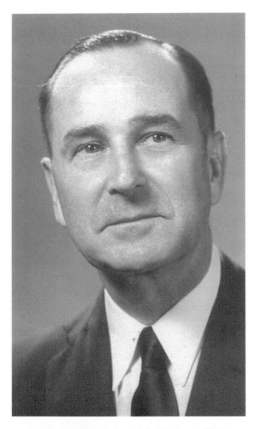

Paul Gaiser, Superintendent

"Among the people crowding rapidly into this old and rather conservative community was a veritable flood of children which swamped the school system." So said Dr. Gaiser, remembering the World War II years. He had been appointed superintendent in 1938 for a school system that had been little changed for decades. He coped with the population explosion of those years and remained superintendent until he became president of Clark College in 1952. Gaiser Hall on the Clark College campus is named for him. (Left, *Vancouver Columbian*; above, Clark County Genealogical Society.)

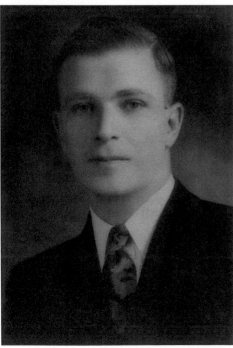

Ralph Carter, Idealist

Dr. Ralph Carter, a dental surgeon, was the mayor of Vancouver after World War II. The temporary housing units that had been built on the Heights were being taken down. There was a recommendation that, for every housing development for white residents, there should be a separate but "just as nice" development for blacks. Concerned for the future of the city, he formed a Human Rights Council, to which he invited blacks and whites, churches and businesses. Their recommendations for a completely integrated community went forward and became the policy of the city. (Vancouver Elks Lodge No. 823.)

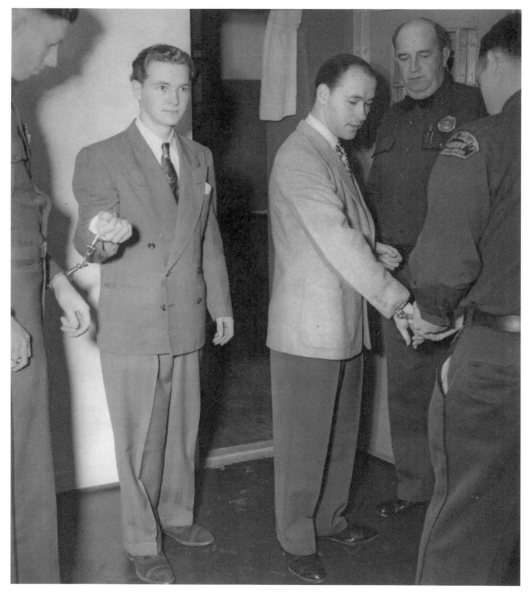

The Wilson Brothers Murder Trial

Nothing has divided the community of Vancouver as much as the trial of the Wilson brothers, Utah and Turman, for the kidnap and murder of Joann Dewey of Meadow Glade. The city had never had such a crime. Dewey had been walking from the Greyhound Bus Depot to St. Joseph's Hospital. Joann had missed the last bus to Meadow Glade, and she was hoping to spend the night at the hospital and catch a ride home with one of the nurses. When she reached the Academy Apartments at 12th and C Street, she was dragged into a car and spirited away. Several days later, her body was discovered in the Wind River in Skamania County. Weeks later, Utah and Turman were arrested for the crime. Vancouver and all of Clark County followed the trial raptly, lines forming in the morning for admission to the courtroom. The guilty verdicts were met with cheers and tears. Both men were hanged at Walla Walla. The division in the city has carried down through the years, with the factions supporting guilt or innocence still emotional about the case. (Author's collection.)

Harry Diamond, Chief

The longest-serving police chief in Vancouver's history, Diamond served from 1945 to 1962. He had been appointed to the department by Mayor Ed Hamilton in 1935. He once told the story that he had arrested the Soviet fliers in 1937 for landing on a military field. He spoke no Russian, they spoke no English, and so no one ever knew of the arrest. He was assigned to guard the plane, however. When the freeway was cut through town, the raw earth cuts on the side offended him, so at night he would drive along in a police car and scatter wildflower seeds. In the spring, the Highway Department was amazed at the display. Upon retirement, he became a chief deputy US marshal in Seattle, but kept his Vancouver home. (Vancouver Elks Lodge No. 823.)

Mel Shevach, Merchant

"The Merchant Prince of Downtown," Shevach graduated from the University of Oregon in 1938. The next year, at just 24, he opened Melvin's Men's Store at 901 Main Street. The next year he married his wife, Jo. Both ventures were successful. Mel competed with three department stores downtown and still grew the store. As was the custom then, merchants met at a downtown café, made plans, and shared stories. That's where they talked him into running for the city council. He served for six years, then was president of the Vancouver Chamber of Commerce, served on the hospital board, and was a director of First Independent Bank. But malls were built, freeways cut across the city, and customers dwindled. After 56 years, Mel closed his store. He said it was "like a death, it's very traumatic. This is a second home to me." (Greater Vancouver Chamber of Commerce.)

John Gunderson, Funeral Director

John Gunderson retired from the 104th Division Timberwolves Army Reserve with the rank of lieutenant colonel. He had served in both World War II and Korea. A graduate of the University of North Dakota, he had used the GI Bill to attend the San Francisco College of Mortuary Science. He bought the Knapp Funeral Home in 1960, then the Hamilton-Mylan Funeral Home, and merged the two into one business. The building (pictured), which has been used in filming television shows, was built as a house in 1853. It had been converted to a funeral home in 1917 and still serves the same purpose. Gunderson was an active community member, belonging to the Elks No. 823, the Washington No. 4 Masonic Lodge, veterans' organizations, and the chamber of commerce. (Right, Greater Vancouver Chamber of Commerce; above, author's collection.)

Robert DuBois, Developer

Robert DuBois started out working in the family lumber business, then tried his hand in the automobile world. He achieved success as a Realtor and developer. First he developed Lakewood, by Vancouver Lake, then the neighborhood of Braewood, on the Heights, which became known as DuBois Park. The city park on Palo Alto is named for him. He was chairman of the City Planning Commission and served as chairman of the chamber of commerce. He was named First Citizen of Vancouver in 1955. (Greater Vancouver Chamber of Commerce.)

Hal Corwin, Pepsi

Hal started working in a bottling plant in Oregon at 19. In 1938 he came to Vancouver, and, with his wife, Barbara, and her parents, Kyle and Laura Kendall, founded the Pepsi Cola Bottling Company. The business was growing when he went off to fight in the South Pacific during World War II, leaving his wife to run the plant. At one point, it had to shut down for lack of sugar. So Barbara headed off to Washington, DC, to plead for a ration increase because of the Barracks and the shipyards. Barbara and her parents held the company together until Hal's return, and after the war it resumed its growth. In 1964, Hal was appointed to fill a vacancy on the city council, but when election time rolled around, he decided not to run for a full term in the office. Everything he did had a spirit of fun about it, his friends said. He loved the city; the city had been good to him. (Greater Vancouver Chamber of Commerce.)

Willie Nelson, Musician

Willie Hugh Nelson was born during the Great Depression. He started in music early, writing his first song at the age of seven. He played with bands while still in high school, tried the Air Force, tried Baylor University, and began working as a disc jockey. He came to Vancouver and went to work for KVAN Radio at their studio on Main Street. While he worked in Vancouver, he wrote "Family Bible" and recorded "Lumberjack." In 1960, he signed a contract that allowed him to travel with the Ray Price Band. He left and carved a memorable musical career. He returned to Clark County to do a concert for the city's 175th Anniversary Celebration. (Author's collection.)

Hermine Decker, Playwright
Hermine has been called the grande dame of local theater. She graduated from Washington State University, where she had a long romance with broadcaster Edward R. Murrow. She came to Vancouver and became the head of the theater and drama department at Clark College. The Decker Theater at the college is named in her honor. One of her plays, *The Festered Lily*, was named Best Play on American Life in 1949. With her good friend Bob Hidden, she helped save the Slocum House from demolition. She became the first president of the Slocum House Theater after it was moved to Esther Short Park. (*Vancouver Columbian.*)

Harold Kern, County Head of the National Youth Administration
Harold's ambition to attend the US Naval Academy as a young man was destroyed when he contracted polio. Although permanently disabled, he had an extraordinary life. He was the county head of the National Youth Administration during World War II. He set up classes for young people to help them qualify for scarce jobs. One of the classes was auto mechanics, and one of the cars they had restored was chosen to chauffeur Eleanor Roosevelt during her visit to the shipyards. During the tour, one of the wheels fell off. Kern nonchalantly ordered another car. He went on to a three-decade career with Clark Public Utilities. (Greater Vancouver Chamber of Commerce.)

Larry Hobbs, Chamber of Commerce Head, and Miss KGW
Unfortunately no one has been able to identify the young lady dressed as a broadcast tower, nor the person who designed her costume, but no one was as enthusiastic about Vancouver in his day than Larry Hobbs. That kept him at the head of the chamber of commerce for more than 25 years. He joined every activity that he happened upon, including the Miss Washington Pageant. In 1965 he received the First Citizen award. His business card read "has mouth, will travel." The occasion of the visit by the broadcast tower was that the television station wished to hand a certificate to the chamber of commerce, proclaiming the City of Vancouver as a member of the KGW family. (Greater Vancouver Chamber of Commerce.)

Richard "Dick" Larson, Florist

The first Larsons to open a florist shop were Dick's parents, who came to Vancouver from Iowa. After his father's death, Dick took over the business, then at 22nd and Main Streets. He ran it until World War II, when he closed it and went to work in the shipyards. After the war, he began again at 9th and Main Streets downtown. His son, Jim, would in his turn take over as the third-generation florist. Dick was a commissioner for the Port of Vancouver for 30 years. (Vancouver Elks Lodge No. 823.)

Gretchen Fraser, Olympian

Standing in the starting gates for the downhill slalom at the 1948 Winter Olympics at Oslo, Gretchen was a long way from Vancouver. She had left her bookkeeping job at the Totem Pole restaurant to compete. All of Vancouver stayed by the radio to hear the live coverage. The start was delayed for a tense 14 minutes when the telephone line failed. All she and the city could do was wait. When the gate was released, she sailed down the course and took the first Gold Medal in downhill slalom for any American, male or female. The reporters called her the "flying housewife from Vancouver." The whole city turned out for a parade to welcome her back home. Before this triumph, during World War II, when there were no Olympics, Gretchen taught amputees from the Army hospital to ski. Years later she worked with the Special Olympics to bring skiing to those athletes. She and her husband, Don, who was the captain of the US Men's Ski Team, moved from Vancouver to Sun Valley, Idaho, and she became the resort's spokesperson. She passed away at the Olympics in Oslo, where she had been coaching Picabo Street. (Below left, author's collection; below right, Sun Valley, Idaho.)

Eva Santee, Librarian

Camas had an award-winning, nationally recognized librarian, Eva Santee, shown above helping two unidentified young ladies. At that time, Vancouver had a problem. It badly needed a professional librarian. They offered Eva a huge raise if she would come to work. She accepted, and just in time, it would seem. The Second World War brought a huge boom, which meant a huge need for libraries. As the Housing Authority built wartime cities, Eva convinced them to add libraries, and they became a part of every new neighborhood that they built. She acquired an Army truck for a bookmobile. After the war, she began a campaign for a regional library. One morning, she remarked that she had joined every organization in the county where she could go to lobby for the library, and hoped that no more would organize, because she had no more time left. She urged its formation, arguing efficiency and economy. She would not rest until every agency in the county signed on. At last, in 1963, it came to pass. The voters approved the formation of the regional concept. Today the Fort Vancouver Regional Library is one of the finest in the nation, and Clark County and all its cities signed on, except Camas, which still maintains its own. (Clark County Genealogical Society.)

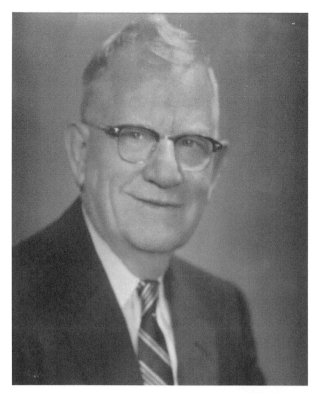

Harry Craig, Merchant

Harry Lampher Craig was a Massachusetts Institute of Technology graduate who became an officer with the Air Service during World War I. He was posted to Vancouver Barracks, where he met and married Norma Sparks, the daughter of Marshall Rowe Sparks, the owner of Sparks's general store. Craig took Norma to California, where he taught high school. They came back to Vancouver to help the elder Sparks operate the store. He gradually assumed management of the store and expanded it into a hardware store. Active in his community, he served on the Vancouver School Board. (Sparks Family collection.)

Norma Craig, General Store Manager

Norma grew up in her father's general store. She had two brothers, Harry and W. Clay. Both went into the automotive business. It was she who had the interest in the store and helped her father run it. When she met the dashing young airman, Harry Craig, her future was set. Marshall Sparks had commented that while two of his sons did not go into the business, his daughter brought him a son who did. Together they managed the business. As her father had done, Norma taught her children the business. (Sparks Family collection.)

James Craig, Business Owner
Shown here as a youth, Jim would grow up in the Sparks store as had his mother. The third generation in the business, Jim attended the University of Washington and earned a degree in business. He came home and bought the business from his parents. He realized that the booming postwar economy was a wave that should be ridden. He moved the company to its present location on Broadway and Evergreen. There it operated as a home supply store selling everything needed for the home. His son, Tom, would become the fourth generation, and together they again shifted the business, now selling furniture instead of general merchandise. (Sparks Family collection.)

Otto Neth, Manufacturer
Columbia Machine is a fixture on Grand, but few in Vancouver know what they make. Otto, Fred, and Walter Neth started a repair shop in 1937. It grew into the world's largest manufacturer of machinery to make concrete blocks. Otto was born in Canada, but grew up in Vancouver. He went into the Army during World War II, serving overseas in ordnance. After the war, he came back to the business. The housing boom after the war brought national attention to the Neth brothers' machines. An entire neighborhood in the Heights was built of concrete blocks from their company. Soon they were selling around the world. After the Armenian Earthquake of December 1988, the Soviet Union flew in their largest cargo plane to carry a machine back to the devastated area. Otto became a port commissioner in 1956 and was simultaneously president of the chamber of commerce and an active Elk. (Vancouver Elks Lodge No. 823.)

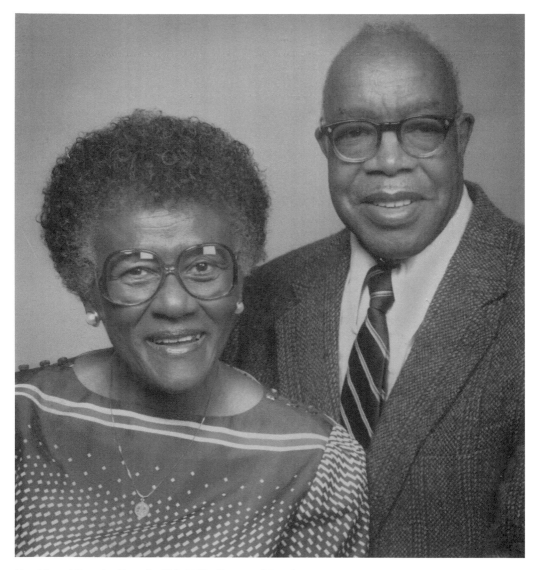

David and Bertha Baugh, NAACP Charter Members

Agelessly elegant, Bertha Baugh shows little outward evidence of the struggles endured by an African American woman who has lived for nine decades. She and her husband, David, were college sweethearts. She became a teacher, but World War II interrupted David's studies. He went into the Army. They came to Vancouver after the war because David's brothers spoke well of the city. He went to work at Crown Zellerbach Paper Mill as a laboratory specialist, and Bertha applied for an opening as a teacher. She was told that folks here "were not ready for colored teachers." Undaunted, Bertha taught in Portland instead, where she stayed for 20 years. Just as she retired, she received her certificate as a John Robert Powers model. The Baughs were charter members of the NAACP and became active in the First Presbyterian Church. David was the master of the Prince Hall Masons in Vancouver, and Bertha supported him by joining the Heroines of Jericho. They were one of the first families to build their home in the Heights. It was not all good; there were taunts and eggs thrown at the house. Bertha still lives there, alone since David's death in 2003. But she believes that they found pride and satisfaction watching Vancouver grow and knowing that they were a part of it. (Bertha Baugh collection.)

Don Stewart, Architect
Stewart lived to be 101. He and his wife, Betty, donated 12 acres of garden land around their home to the city for the Discovery Trail and for a bird sanctuary that is called Stewart's Glen. When they were married, he told Betty that an employer had told him he had to see Greek architecture before he would be worth anything. So they went to Greece. The Vancouver School Board hired him to oversee a project at the old Vancouver High School in the 1930s, and he stayed on to design other Vancouver schools, Hudson's Bay and Hough Elementary. The Stewarts were members of the First Presbyterian Church, and he designed that building on Fourth Plain. It was the structure of which he was most proud. When the city formed its first planning commission in the late 1930s, Stewart was appointed to that board. (*Vancouver Columbian*.)

Arthur "Cap" Haynes, Musician, and Edith Haynes
Born in Cardiff, Wales, and trained at the Royal Academy of Music in London, Arthur followed his music around the world. He joined Her Majesty's Coldstream Guards as a solo cornetist. He organized General Pershing's Band in Paris during World War I. He came to the United States and joined the American Army. For 18 of his 30 years in the Army, he was at Vancouver Barracks, directing the 7th Infantry Band. After retiring, he taught music at Clark College and Vancouver High School. Through it all, he was the band director of the Al Kader Shrine Band. In 1967, at a homecoming game, the band spelled out the name "Cap" on the field as they played music he had written. (St. Luke's Episcopal Church.)

Justice George Simpson, Supreme Court Judge
Justice Simpson opened his law office in Vancouver in 1907, the beginning of a dedicated career. He ran for prosecutor, but lost by 45 votes. He ran for city attorney and won three terms. He then ran for Superior Court judge, and again won three terms. Gov. Clarence Martin appointed Simpson to the Supreme Court in 1937. When he retired after 13 years, he had been responsible for writing a revision of the rules of the court. His clerks called him "the hardest working judge in his era." He would finish his work ahead of time, and then go fishing. Handling juvenile cases had developed in him a deep concern for young people. After he lost his final election, he returned to Vancouver, where he helped organize the St. Helens Council of Boy Scouts and received the Silver Beaver Award from the Scouts. (Vancouver Elks Lodge No. 823.)

CHAPTER FOUR

The Big Change

The 1960s and 1970s were a period of convulsive change for the United States, and Vancouver was not immune. The foundation of the city, the Army, was slowly departing. The Barracks became a subsidiary of Fort Lewis. Bit by bit the Army post faded and the majority of the base was turned over to the community. Schools and government buildings filled much of the land the base had occupied, and streets were cut through to join east and west. The Hudson's Bay Fort was rebuilt on the original site, and piece by piece it has been restored. The post's first construction, Officer's Row, was won from the government by the city. Each year has seen more of the base released to local control. The longtime industries—the brewery, aluminum, fruit canning—disappeared and new industries arose. An influx of high-technology companies created the term "Silicon Forest." St. Joseph's Hospital was gone, a new hospital appeared on the east side of town, and that hospital grew and grew. The 1980s began with a literal bang as Mount St. Helens exploded and focused world attention on Vancouver, where the teams of scientists had headquartered. Again the river's influence was felt when another crossing, the Glenn Jackson Bridge opened and, as the Interstate Bridge had done 65 years earlier, the connection to Portland was made easier. Thousands of people moved into the east side of the county. Where once verdant farms and orchards had grown, housing developments and shopping areas sprouted. If a city had seams, they would have bulged. Suddenly, almost overnight, a new generation of philanthropists arose. Across the city, amenities that were needed in the face of the growth were given, not by government, but by the generosities of businessmen and women who had made their fortunes in the Northwest: swimming pools, hospital towers, libraries, parks and playgrounds, and aid and shelter for women, children, and the homeless. Annexations grew the city to the fourth largest in the state. Nothing would ever be the same. The influence of the Army came to a definitive end on September 15, 2011, when the Army Reserve, the last vestige of the Army's presence at the Barracks, moved out for new quarters in Orchards.

Don Campbell, Publisher

Don Campbell, with his brother Jack, became a co-publisher of the *Vancouver Columbian* newspaper after he returned from serving in the Marine Corps in World War II. He had not wanted to go into the family business; he preferred the work of a printer. As a youngster, he had a toy press in his basement and printed business cards, selling them to classmates. He and his brother Jack became co-publishers. When Jack died suddenly in 1978, Don became the head of the newspaper. Struck by the charm of other cities, Don decided that that charm came from trees on the streets. He donated $10,000 worth of trees to the city and had them planted all over downtown. He planted daffodil bulbs in the green spaces north of the Interstate Bridge. They are still blooming today. (*Vancouver Columbian.*)

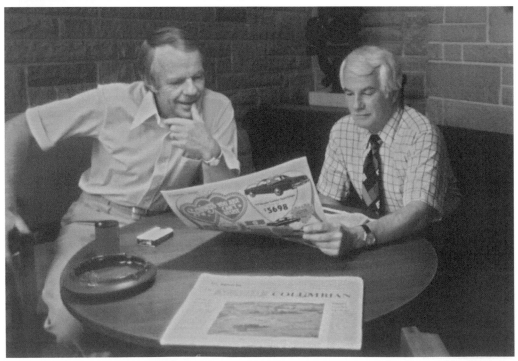

Julia Butler Hansen, Congresswoman
Julia Butler never lived in Vancouver, but she had a tremendous impact on the city. Her political career began when she was elected to the Cathlamet, Washington, City Council in 1938. From there, she went on to the Washington State Legislature, and then she was elected to serve out the term of U.S. Representative Russell Mack. She would serve for six consecutive terms. Mack had worked to establish the fort site, but his untimely death ended that effort. Julia Hansen's first bill was to set the land aside under the National Park Service and begin the reconstruction. An almost identical bill was presented in the Senate, and it passed with little opposition in June 1961. (*Vancouver Columbian.*)

Willard Nettles, Councilman
Willard Nettles was Vancouver's youngest city council member, at just 26 years of age, and, to date, its only African American councilman. He was born in Texas, one of 10 children. The family settled in the Heights section of Vancouver, where Willard grew up and attended Fort Vancouver High School. He excelled in athletics, particularly track and wrestling. He carried those abilities to Lewis and Clark College and in 1963 was a champion in broad jump and triple jump. He earned his master's degree in education and taught Spanish at Fort Vancouver and Columbia River High Schools. He retired from teaching in 2009 and has since won medals for his wine-making. (Willard Nettles collection.)

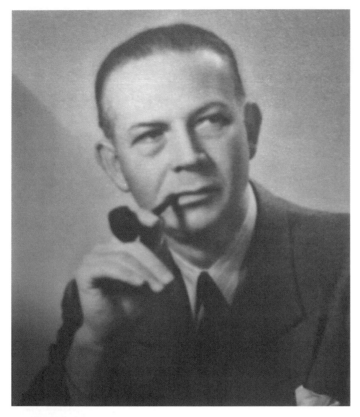

Day Hilborn, Architect
Vancouver residents are familiar with Hilborn's work whether they know it or not. His biggest work was the Clark County Courthouse (pictured), completed in 1939; it was built of molded concrete, a first in the city. The Kiggins Theater on Main Street is the most familiar, and, at the other end of Main, the Kiggins Bowl in between, the first United Methodist Church at 401 East 33rd Street. One work that few know, however, is the little mill that is hidden away in Whipple Creek Park. Hilborn was a city man, but loved the calm of the country. He bought the land that is now the park in 1949 and built the mill. (Left, *Vancouver Columbian*; below, author's collection.)

Freeman Keller, Straight Shooter

In 1957, Freeman built his first subdivision, Bagley Downs, on the site of an old racetrack. The houses cost around $12,000, but young people starting out still had to stretch to make the $64 a month payments. One customer remembered that they had a refrigerator, but did not have enough money for a stove; Freeman took the stove that his mother used for canning and gave it to them. He and his wife, Betty, had two sons and a daughter. One of his daughters, Mary Crawford, died of kidney disease. Two transplants extended her life for 17 years. Donate Life Northwest became an important charity to Freeman after that. (Greater Vancouver Chamber of Commerce.)

Jim Justin, Civic Leader

Jim's greatest love was flying; his unattained ambition was to obtain a pilot's license. He remained in the Air Force Reserve for 30 years after his active service and retired as a colonel. After his active duty service, he returned to civilian life and took over his father's photography business, Justin's Photo Mart. Jim was always the person that the community called upon to get things done. He ran for and was elected to the city council. He served there for 10 years and was mayor for four. (Greater Vancouver Chamber of Commerce.)

Harley Hall, POW/MIA

The last Navy casualty of the Vietnam War, and the last POW/MIA of that conflict, Harley Hall grew up in Vancouver with his two sisters, Gwen and Kay. They remember his daring as a boy; his penchant for risk-taking would carry over to his adult life. He graduated from Evergreen schools and from Clark College in the class of 1957 and then left Vancouver to join the Navy. Harley had a stellar naval career. He was the youngest officer to be promoted to commander. In 1970, he was named as one of the Nation's Outstanding Young Men, and Clark College named him as an outstanding graduate. The Blue Angels offered the next adventure: the Navy's demonstration team travels the world performing breathtaking precision maneuvers. Only pilots of proven ability have the chance to try out for the Angels. Hall not only made the team, he became the "Boss," the executive officer. He was a husband and father; he and his wife, Mary Lou, had two children. In January 1973, he was the executive officer of Fighter Squadron 143, aboard the USS *Enterprise*. He and Lieutenant Commander Phillip Kientzlert launched in an F-4J Phantom. Just 10 hours before the Paris Peace Accords were to end the Vietnam conflict, Harley was shot down. He tried to head out to sea, but flames erupted, forcing him and Kientzlert to eject. Kientzlert reported that they were taking ground fire, and he believed Hall had been killed. Kientzlert was captured, and his captors told him that Hall had been killed. However, another pilot saw Hall on the ground, gathering his gear, then running into the jungle. That was the last time anything certain was known about Harley Hall. Days later his status was changed from "missing" to "prisoner." Many years later, his family received a packet containing teeth and fragments of bone. But of that radiant young man, nothing at all. (Gwen Hall.)

Brian Ingram, Ransom Recoverer
The only part of the ransom money paid to the mysterious D.B. Cooper by Northwest Airlines ever recovered was discovered in Vancouver in 1980 by young Brian Ingram. In 1971, a man identifying himself as Dan Cooper hijacked a Seattle-bound plane. He extorted $200,000 and parachuted somewhere over Southwest Washington. Nine years later, eight-year-old Brian Ingram dug up a pouch with 299 soggy $20 bills. The serial numbers proved that they were part of Cooper's loot. The trove did Ingram little good, however. The money was divided between his family and the airline's insurance company. Years later, when he tried to sell his share, he was hit with a $64,000 back child support charge. Every aspect of the D.B. Cooper story seems fraught with bad luck. (Left, *Vancouver Columbian*; below, Federal Bureau of Investigation.)

Gale Bettesworth, "A Man of the Decade"

Bettesworth was called, upon his death at 51 in 1971, "A Man of the Decade." Described as a quiet and modest man, he began working in high school as a janitor in the courthouse. He also earned a quarter an hour hauling bricks. Then as an adult, when he was a successful bank manager, he chaired Camp Fire Girls, Boy Scouts, and the Lions Club, coached blind athletes, and was president of the Red Cross, the Toastmasters, and eventually the chamber of commerce. When complimented on his contributions, he said, "It means that I haven't spent much time at home." The most sincere accolade bestowed by the *Columbian* newspaper was that "His was the dependable, dedicated, long-lasting service which makes communities worthwhile places in which to live." (St. Luke's Episcopal Church.)

Sam Elliott, Actor

Veteran actor Elliott graduated from David Douglas High School in Portland and received an associate's degree from Clark College. He was cast as one of the leads in the college production of *Guys and Dolls*, and the *Columbian* newspaper remarked that he should become a professional actor. Perhaps he took that advice to heart, for it was not long afterward that he announced his plan to go off to Hollywood. There are still women in Vancouver who dated Sam in college, but all they will say is that he was just as you see him today, a very quiet young man. (Author's collection.)

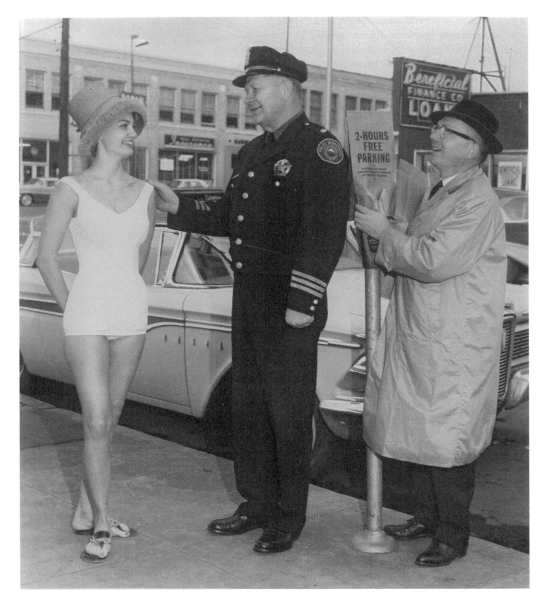

Ed Mayo, Officer and Musician

The fetching young woman in the bathing suit and lampshade-style hat is tentatively identified as Miss Eugene, Donna Morasch. The raincoat man, however, remains unidentified. Ed Mayo had two loves, law enforcement and music. He was a trumpeter with the 7th Infantry regiment, and, after buying his way out of the Army in 1940 for $90, he answered an ad for the Vancouver Police Department and was hired at once. He reenlisted in the Army in 1944, serving as an MP. When he was discharged, he was again immediately rehired by the City of Vancouver. He remained with the 104th Reserve Infantry Band for 12 years. That added up to 20 years in the Army and brought him a pension. At the same time, he was going to night school and earned a law degree, which he never used. When Chief Harry Diamond retired, Mayo, nicknamed "Gentleman" Edward Mayo, was appointed to that position. He retired and was immediately hired by the County Assessor's Office. He resigned that job to travel to England with the Brahms Singers. (Greater Vancouver Chamber of Commerce.)

George Propstra, Philanthropist
The gruff-voiced spokesman for his own television commercials, Propstra took the idea of a hamburger stand to its maximum. His father had had a creamery in Ridgefield and moved the family to Vancouver when George was an infant. The Holland Creamery sold sandwiches and ice cream, and then gradually changed into Holland Restaurant. He heard of the then 10-cent hamburgers and gave it a try. During the next three decades, George would open 32 Burgervilles and three Holland Restaurants. He loved to fly, gaining his pilot's license, first in fixed-wing aircraft, then in helicopters. He began to give to the community. At first his donations were anonymous, but then he found that it was fun. He and his wife, Carolyn, donated more than $13 million to the community. To the schools, he donated two swimming pools and a brick stadium at Hudson's Bay High School. To the City he gave $3.2 million for the plaza and bell tower in Esther Short Park. Beyond his philanthropies, he inspired other businessmen to give back to the community. Just before his death at 94, he was making plans to open a bakery on Main Street. His daughter and son-in-law, Tom and Kathy Mears, are still involved in the Holland Corporation. (Kathy Propstra Mears.)

George Goodrich, Restaurateur

The Totem Pole, the Crossing, the Quay—all three iconic restaurants were the brainchildren of Goodrich, a transplant from Oklahoma and California. Only the Quay remains (pictured). He bought the Totem Pole Restaurant on Highway 99 in 1940. During World War II, he tried to stay open to serve the shipyard workers but had to shut down two days a week for lack of food. He developed the idea of a riverside restaurant during a trip to Hawaii, noting that there was no place in Vancouver to dine and enjoy the panorama of the river. He didn't have the $150,000 necessary, he once said, but had 15 friends with $10,000 each. It was enough money to convert an old prune warehouse at the port to a then trendy nightspot in 1960. The neighboring hotel came along three years later. He felt the Crossing on 8th Street reflected the connection that Vancouver owed the railroad. He bought old railroad cars and connected them together with a depot-like structure at the center. It was the last restaurant that he opened. (Greater Vancouver Chamber of Commerce.)

Kyle Corwin, Corwin Beverage Company

It would be a child's dream to grow up in a Pepsi plant. Kyle worked in his parents' bottling company from the time he was a child, learning the business. He took time out to graduate from Central Washington University and serve in the Navy, but came back to the company. Every public event would be marked by Pepsi dispensers and the familiar red and blue cups, and Vancouver buses (no longer extant) sported Pepsi caps. Although he was elected to the school board and served from 1982 until 1990, he did not take a public political stand. He would happily work with whoever was elected, and help where he could. No request from a neighborhood organization, school, or club for free soda was ever turned down. He, his family, and employees worked long into the night every year to prepare for Vancouver's Fourth of July event. But it had to be fun for Kyle. Even as he worked with other businessmen to remake the downtown, he reminded them to enjoy what they were doing. Left, *Vancouver Columbian*; below, Corwin Beverage Company.)

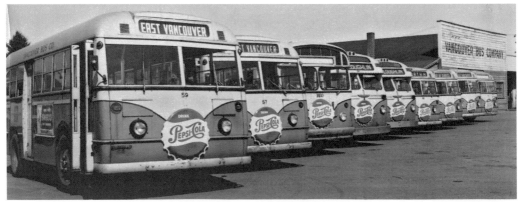

Albert Angelo, Builder

From the son of Italian immigrants in Skamania County to the most recognizable developer in Clark County, Angelo made it look easy. He moved to Vancouver in 1940 and was advised to build houses for the many railroad and aluminum workers arriving in the city. He took that advice, bought land near 45th Street and Columbia, and built his first project. He built others and formally began the Al Angelo Construction Company in 1947. In 1962, he was elected to city council and became mayor in 1966. His commercial endeavors are ubiquitous in the city. He was known for always being a gentleman, open and approachable. He declined to run for reelection as mayor because he wanted to spend more time with his family: his wife, Kathryn, and five children. Two of his sons, Albert "Corky" and Craig, followed him into the business and a third generation has joined them in Albert III. He was always available for advice and opinions and met regularly with subsequent mayors and council members for coffee and conversation. (Angelo Family collection.)

Emil Fries, Piano Hospital

The State School for the Blind taught two trades: piano tuning and broom making. The brooms were sold to raise funds for the school. In 1949, both of those programs were cut. Emil disagreed, holding that piano tuning was a trade in which the blind could outperform the sighted. He mortgaged everything that he owned to start the school and the Piano Hospital. Today it is the only one in the nation, and students travel to Vancouver from all over the world. When he was a child, and complained to his mother that he could not see something, she would reply "but you can feel it." That became the title of his autobiography. (Washington State School for the Blind.)

Allan Weinstein, Cofounder of SWIFT
Weinstein was a serious businessman with a wicked sense of humor. He believed deeply in returning his success to the community. He served as one of the founders of the longtime successful charitable organization SWIFT, Southwest Washington Independent Forward Thrust. One of his favorite fundraisers was Peanut Butter and Jam, a street dance with a live band whose only admission charge was cans of food for the food bank. From his wares as president of Vancouver Furniture, Allan donated beds and bedding to homeless shelters, equipped the Child Abuse Intervention Center with kid-friendly furniture, and initiated fundraisers for the YWCA and many other charities. (Greater Vancouver Chamber of Commerce.)

Edward Schofield, Schofield Properties
Schofield, with his sister Patricia, grew up in Vancouver. They were the grandchildren of Edward R. and Mary Schofield. He had a daring streak; as a young man, he rode a bicycle from Southern California home to Vancouver to prove that he could. He worked as a tour guide in Yellowstone National Park and travelled across the country selling magazines. The rest of his career was spent in sales. In 1995, he returned to Vancouver to take over the family business, Schofield Properties. Ed had a passion for the city and invested time and money into revitalizing downtown as well as his own properties. Downtown flower baskets were his special love. He invited friends and neighbors to the roof of the Schofield Building every Fourth of July to watch the fireworks. The commercial structure at McLoughlin and Main Streets has been renamed Schofield's Corner. (Right, Schofield Family collection; below, author's collection.)

Stan Bishoprick, Timberman
A 1934 graduate of Oregon Agricultural College with a degree in forestry, Bishoprick began working for the Dant and Russell Lumber Company after a short stint in British Columbia. He went to Shanghai to represent the company in 1936 and stayed there until 1941 when he was elected as vice president. While in Shanghai, he built a teak sailing boat, which he lost during World War II. He built a home on the Columbia River, and built a new boat, the 56-foot *Corahleen*. He and his family sailed the boat to Hawaii in the Trans-Pacific yacht race. He was on the board of the State Steamship Line, headquartered in Vancouver. The company had begun as a way to ship lumber, and it grew to a freight/passenger line. He would frequently call friends and take them on spontaneous trips aboard the Line's ships. (Bishoprick Family collection.)

Valeria and Daniel Ogden, Politics and Nonprofit
The Ogdens have a true partnership. They work together both in the political scene and in the nonprofit world. Dan is a former professor of political science at Washington State University. At one time he was an advance man for the John F. Kennedy campaign as it moved through the South and East. The couple could often be seen campaigning together, Dan on one side of the street, Val on the other. Valeria was the director of the YWCA in Clark County and left that post to run for the State Legislature. She would be elected to six terms. Her focus was on issues affecting women and children, and on the needy and disabled. Around the city, there are buildings and rooms named for Val, all of them dedicated by those nonprofits that she has helped. (Val and Dan Ogden collection.)

Jim "Bubba" Larson, Fourth of July Celebration Volunteer
Larson grew up in Vancouver's Armada neighborhood. His father owned Larson's Florist on Main Street, and Jim ran the shop for years after his father's death. He installed a small ice-cream stand at the rear of the store called "Bubba Two Scoops." When he closed the florist, he moved "Two Scoops" to Hazel Dell, then back to downtown Vancouver. He served as a fire commissioner for District 6 for many years, helping to make the transition from an all-volunteer department to one with career firefighters. But those accomplishments are not what the people of Vancouver most remember. He started volunteering at Vancouver's Fourth of July celebration. He and his crew dug trenches at the fort and lit the fireworks by hand, making sure to brush sparks off each other's clothing. The celebration grew, and eventually automation and computers took over the detonations, but Bubba would be there, overseeing every detail for four decades. The show was always on the brink of collapse, but year after year, Bubba made the gigantic free show happen. That energy flagged with age and illness; the grand finale of the 2008 show was dedicated to Jim, with the shells donated by the supplier. (Traci Larson.)

Ed and Mary Firstenburg, Philanthropists

Around Vancouver are countless evidences of the Firstenburgs' philanthropy. Their $15 million gift to the medical center was at the time the largest gift in the city's history. It built the massive surgery wings that soar above Mill Plain Road. But they had not always been able to give with such largesse. Ed had wanted to be a banker, but the Great Depression got in the way. He was a teacher when he met Mary. She intended to be a missionary until Ed came along. On 1936, Ed finally found a job at the Ridgefield State Bank. His dedication to customer service helped the bank to grow, and eventually he became majority shareholder and then bought the bank outright. He merged several local banks into First Independent Bank. He never really retired; he formally retired after 69 years, but started a tiny First Independent Bank branch in the lobby of the Waterford Retirement Community. He and Mary had given the student commons building at WSA Vancouver; donated $1 million to the Skills Center built the Firstenburg Center in East Vancouver, a place for children to play; and provided dozens of other gifts. When Mary passed away, they had been married for 72 years. He followed her the next year. (First Independent Bank.)

Bruce Hagensen, Rehabilitation of Officer's Row
Shown here walking with Chief of Staff Colin Powell, Hagensen was in the lead to bring the Congressional Medal of Honor Society to Vancouver. He was also a leader in the effort to secure Officer's Row from the federal government. Once Officer's Row was acquired, the effort began to restore and make the buildings pay for themselves. The Row is now a jewel in the heart of the city. That accomplishment, along with the rehabilitation of the area, brought Vancouver its second All-America City award. (City of Vancouver.)

Col. Joe Jackson, Medal of Honor Recipient
Joe Madison Jackson has had a presence in Vancouver, although he has never lived in the city. Colonel Jackson received the Congressional Medal of Honor for his actions in Vietnam as the pilot of a C-123 aircraft. He flew into an airstrip that had been overrun, engulfed in flames, under heavy rocket fire, with eight destroyed aircraft still on the field. That reduced the usable length to 2,200 feet. Jackson volunteered to land his aircraft and rescue a three-man team. When the City of Vancouver lobbied to host the National Convention of the Medal of Honor Society, Jackson was one of the committee that chose the city that year. Since the convention, Jackson began visiting the city from his home in Kent and has been a regular attendee at most "Celebrate Freedom" events. (Author's collection.)

Reid Blackburn, Photojournalist

In 1980, Blackburn was only 27 but had worked as a photographer for the *Vancouver Columbian* for six years. Coworkers would later remember his humor, as in the time he filled the photo editor's coffee cup with cigarette butts in an emphatic anti-smoking message. He met his wife, Fay Mall, there, but the two would enjoy only nine months of marriage. His talent as a photographer had attracted widespread notice. He called it "painting with light." So when Mount St. Helens began to stir, he was chosen to cover the story, not just for his paper, but for *National Geographic* and the United States Geological Survey as well. He was known not only for his talent, but for his skill in the wilderness and his knowledge of the mountain, which he had often climbed. Reid set up at Coldwater camp, eight miles from the crater. The area was believed to be safe. No one expected a lateral blast. He had just enough time to get into his car when the pyroclastic flow struck the camp. His friends, his wife, and his coworkers at the paper waited in vain for his call. The car with his body inside was found four days later. (Fay Blackburn.)

David Johnston, Volcanologist

There are two quotes that are memorable regarding the eruption of Mount St. Helens on May 18, 1980, both said by Johnston. The first: "Being on the mountain is like standing next to a dynamite keg and the fuse is lit." He constantly warned others of the extreme danger that the mountain presented. The second is "Vancouver, Vancouver, This is it! This is it!" Those were the last words he would ever utter. Mount St. Helens erupted in a lateral explosion that sent a pyroclastic flow of superheated gas and debris at speeds estimated at up to 670 miles per hour. He was just 30 years old that morning and taking another geologist's shift on the mountain. The photograph was taken just 13.5 hours before the blast as he sat in camp. It was not his first foray into danger; he was trapped on an erupting Mount Augustine in Alaska when high winds grounded evacuation aircraft. In 1993, pieces of his trailer were found as workers excavated the Spirit Lake Memorial Highway. No trace of Johnston has ever been found. (United States Geological Survey.)

Steve Oliva, Philanthropist of the Year

Hi School Pharmacy stood across the street from Vancouver High School, hence the name. It did a good cigarette and candy business, and the soda fountain was a popular gathering place not only for students but for the neighborhood. When the school closed, everyone knew the business was doomed. Oliva, with a new wife and a new pharmacist's degree, saw the store. He did not have much money, and the store was a bargain. He thought he could make a go of it and get enough money to move to California. Since there were drugstores in almost every block of Main Street, he concentrated on service, even delivering filled prescriptions. He was among the first to ban the sale of cigarettes in his store, saying that the store's purpose was to improve health, not harm it. The business grew; he added hardware to the mix. He eventually had 25 stores to form the largest family-owned corporation in Washington. A member of the new philanthropic generation, Steve and his wife, Jan, have given to Boys and Girls Clubs, the library, the college, and so many others that they were named Philanthropists of the Year by the Community Foundation. Oliva never made it to California. (*Vancouver Columbian*.)

Ray Hickey, Riverman
The former owner of Tidewater Barge Lines was the youngest of 10 children born to Wesley Hickey, a miner, and his wife, Clara. He quit high school in the 10th grade and joined the US Marine Corps in 1945. After the war, he followed his father into the mines, but soon he was reading the want ads. He answered an ad for a deckhand at Tidewater Barge. Some training in diesel mechanics won him a spot in the engine room; he then moved up to general manager, became company president by 1977, and bought the company in 1982. He sold the company in 1996. The wealth that he created was used to make a difference. He donated $20 million for local projects, the Renaissance Trail, the Ray Hickey Hospice House, the YWCA, the Columbia Land Trust, and Doernbecher Children's Hospital. When Ray first proposed developing Tidewater Cove, the place on the river where his company had started, he was asked what he would do if it didn't happen. He replied, "I'm an old river rat, if I lose it all, I'll just go back to being a river rat." He wrote a book about his life, aptly titled *Don't Tell Me It Can't Be Done.* (Royce Pollard collection.)

Royce Pollard, Mayor

One of Vancouver's most colorful and sometimes controversial mayors was Royce Pollard. He followed the tradition of Vancouver Barracks commanders staying in the city. He served 27 years in the Army with tours in Europe, Korea, Japan, and Vietnam. He and his wife, Margaret, moved 19 times in those years. Like Vancouver's first mayor, Levi Farnsworth, Royce was born in Vermont, in Burlington. Royce's love for his adopted city showed clearly during his 20 years in public office. He coined the nickname "America's Vancouver" to differentiate it from the younger city in British Columbia. When a derelict pushed Royce with a shopping cart and told him to get out of "his park," Royce began the rebirth of Esther Short Park, which was then called "man down" park by public safety, into a treasure in the city. He shepherded the growth from a city of 46,000 into a city of over 165,000, the fourth largest in the state. A derelict brewery in the heart of town came down to be replaced by shops, condos, and apartments. Connecting 192nd Avenue with Highway 14 created a magnet for shops, businesses, and a new Clark College campus. He took great satisfaction in effecting the reconciliation between the City, the Army, and the Nez Perce Nation, healing scars left since the Indian Wars. Royce lost his last bid for reelection in 2008. (Royce Pollard collection.)

Ed and Dollie Lynch, Partners

The Lynches were not only the first couple chosen as Citizens of the Year together, but they were also appointed by Lieutenant Governor Brad Owens as Washington "Generals" together. They were grand marshals together of the Vancouver Veterans Day Parade, and named, again together, as Philanthropists of the Year by the Community Foundation of Southwest Washington. Ed and Dollie were a team that made Vancouver their beneficiary. They arrived together when Ed came to the city with Kiewit Pacific. Ed started Identity Clark County after his retirement, an organization devoted to creating the community they believed in. Without Ed, the Vancouver Heritage of Trust would never have been. They gave $1 million to Southwest Washington Medical Center, and in 2002 they gave 9.6 acres north of their home to the Community Foundation of Southwest Washington. When Dollie passed away in 2010, Ed said, "She had 84 good years, and I had 62 good years with her." (Ed Lynch collection.)

Leverett Richards, Adventurer

Leverett's first story for the *Oregonian* newspaper was published in 1931; his last was in 2000. He travelled to both poles, eventually flying to the South Pole 14 times. He visited 75 countries between the two. He was an aviator and wrote a book, *TAC: The Story of the Tactical Air Command.* He flew a seaplane onto the Columbia River during the 1948 Memorial Day Flood that destroyed Vanport, Oregon. Many years later he flew into the ash cloud rising from Mount St. Helens. In 1937, he covered the landing of the Soviet transpolar flight piloted by Valery Chkalov. Some years later, he slept with the elephants at the Portland Zoo the night Packy the elephant was born. From that experience came the title of his book *Elephants Don't Snore.* His was the first plane to land in Anchorage after the 1964 earthquake. He married Virginia Durkee in 1934, and they built a house on Buena Vista where they indulged their love of gardening. There is both a Leverett Richards rhododendron and a Virginia Richards rhododendron. They had two sons, Durkee and Elmo. Both of them devoted long hours to the Arc of Clark County and the Grandview Group Home to support their son Elmo. Durkee and his family now live in Sequim, Washington. (Above, *Vancouver Columbian*; inset, author's collection.)

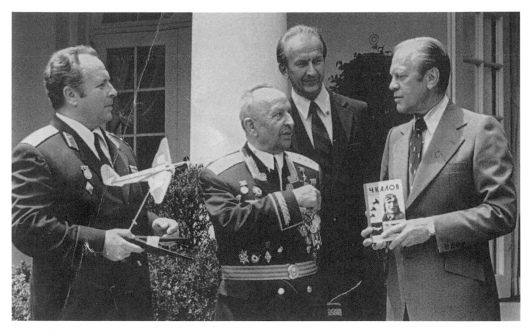

Igor Chkalov, Ambassador for Russian-American Relations
Shown here with Georgi Baidukov and Pres. Gerald Ford, the son of Soviet pilot Valery Chkalov, Igor became an ambassador for his father and for Russian-American relations. He first visited Vancouver at the occasion of the dedication of the monument to his father's flight. He remarked at the renaming of 112th Avenue as Chkalov Avenue, then a quiet country road, that he thought it would be a busy street some day. He was right; Chkalov and Mill Plain is the busiest intersection in the city today. The monument was first installed in a small landscaped area between Pearson Field and a park and ride off Highway 14. When the Highway was widened, a new place had to be found. The perfect site was on the north side of the runway at Pearson Field, where General Marshall would have met the pilots. There it was installed, and again, Igor visited, carrying red flowers to place at the site. (Author's collection.)

Erwin O. Rieger, Outdoorsman
Rieger was longtime managing editor for the *Vancouver Columbian*. He was a tough but inspiring editor and is remembered more for his advocacy of nature than for that occupation. His book, *Up Is the Mountain*, chronicles his life as he scaled almost every peak in the Cascades Range. In the 1930s, Rieger joined the Masonic Lodge in Vancouver and quickly rose to the chair of master. He devoted the same intensity to his concern for youngsters. He was a champion of Scouting and has been called a "Champion Scoutmaster." His troop had more Eagle Scout projects than any other in the region. As he reached the end of his life, the movement began to honor him while he was still alive. The portion of State Route 501 that curves by Vancouver Lake was named the Erwin O. Rieger Highway in 1971. He died the following year. (Vancouver Masonic Center.)

Jack Murdock, Murdock Charitable Trust
The Murdock Charitable Trust began in 1975 with $90 million. That money came from the estate of renaissance man Melvin J. Murdock. He started out selling and servicing radios and electric appliances. He served in the Coast Guard in World War II, where he met his soon to be partners. They developed an oscilloscope, an instrument that was indispensable in the rapidly growing electronics industry. They formed a company that is now Tektronics. Jack loved flying and made many advances in aviation safety. He had a Piper Cub dealership, which he operated out of Pearson Field. That would ultimately lead to his untimely death. While attempting a takeoff in the Columbia River, his seaplane nosed over and flipped in the water. He is presumed to have drowned, although no trace was found of his body. He had never married and had no close relatives. In his will, he remembered some relatives, but left his multimillion dollar estate to charity. The Murdock Trust was formed from that estate. The Jack Murdock Aviation Museum at Pearson Field was just one recipient of funding from the trust. (M.J. Murdock Charitable Trust.)

Ed Rankin, Community Voice
St Luke's Episcopal Church held a bittersweet celebration in 2000. Father Ed Rankin was retiring from the church after 20 years of service. The son of a school superintendent, he ran for the Vancouver School Board and was elected again and again until he retired from that position after 20 years. He often said that he has a conviction that there is a "need to speak for those who don't have the strongest voice." He has, for many years, been active on the Community Advisory Board, which oversees government nonprofit grants and the Free Clinic of Southwest Washington. (St. Luke's Episcopal Church.)

Dale Beacock, Music Man (RIGHT)
A shortage of clarinet players sent Beacock into the music store business. He was a music instructor at Clark College, and his orchestra was short on reed instruments, so he began giving lessons at his home. Eventually he moved into a studio on Mill Plain. There he and his wife, Susan, began the little business that would grow into the successful endeavor it is today. Soon Dale's two children, Russ and Gayle, joined the crew. Dale continued playing in and leading orchestras through the years, with his special interest in school groups. Seniors weren't forgotten; the New Horizons Band was for those who once played or who wanted to. Dale died tragically in 2011 when his bicycle collided with a truck while he was bicycling with his son on an Oregon highway. (*Vancouver Columbian.*)

INDEX